HIGHLAND KNITS

HIGHLAND KNITS

Knitwear Inspired by the OUTLANDER *series*

INTERWEAVE
interweave.com

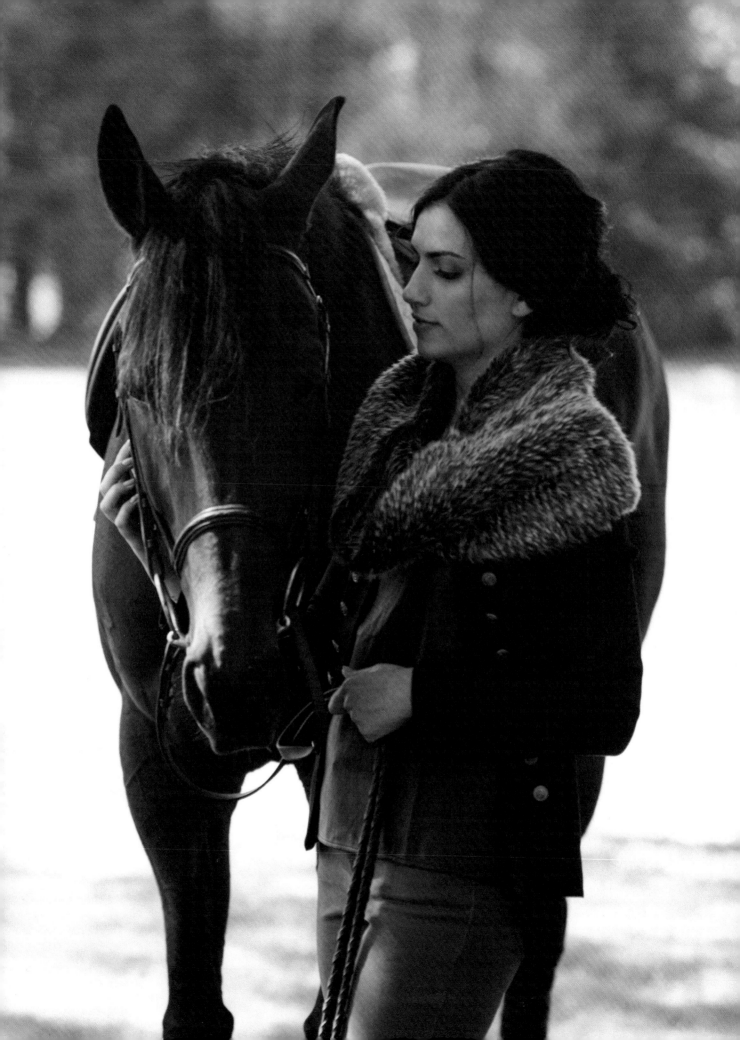

CONTENTS

INTRODUCTION

Oh, *Outlander*, how we love ye . . . the breathtaking drama and raw intensity of Claire and Jamie's romance, the rugged beauty of the Scottish Highland landscape. But perhaps what mesmerizes us most is the texture, the depth, the earthy magnificence of . . . those unforgettable knits. We swoon.

From the "signature" Sassenach Cowl to the fan-favorite Rent Collection Shawl, our *Highland Knits* pattern collection captures the rustic yet undeniably feminine beauty of these *Outlander*-inspired pieces. Evincing the muted yet rich hues of the Scottish hillsides, this sumptuous gathering of chunky, tweedy designs summons the best of both worlds—at once easy to knit and abounding with dramatic impact. Feeling adventurous? Our sixteen gorgeous patterns can be crafted from traditional yarns or your own handspun fibers— but whichever you choose, the story is all yours.

And while Claire may have donned her beloved knitwear against the back-drop of eighteenth-century Castle Leoch, you'll find these evocative pieces embody a classic sensibility and versatility that effortlessly transcend time. Corset, tartan, or your favorite well-worn denim, they all have a place in *Highland Knits*.

Now, we invite you to lose yourself in the romance, the character, and the drama of the coming pages—and hope to inspire you to create pieces you're sure to fall in love with over and over and over again.

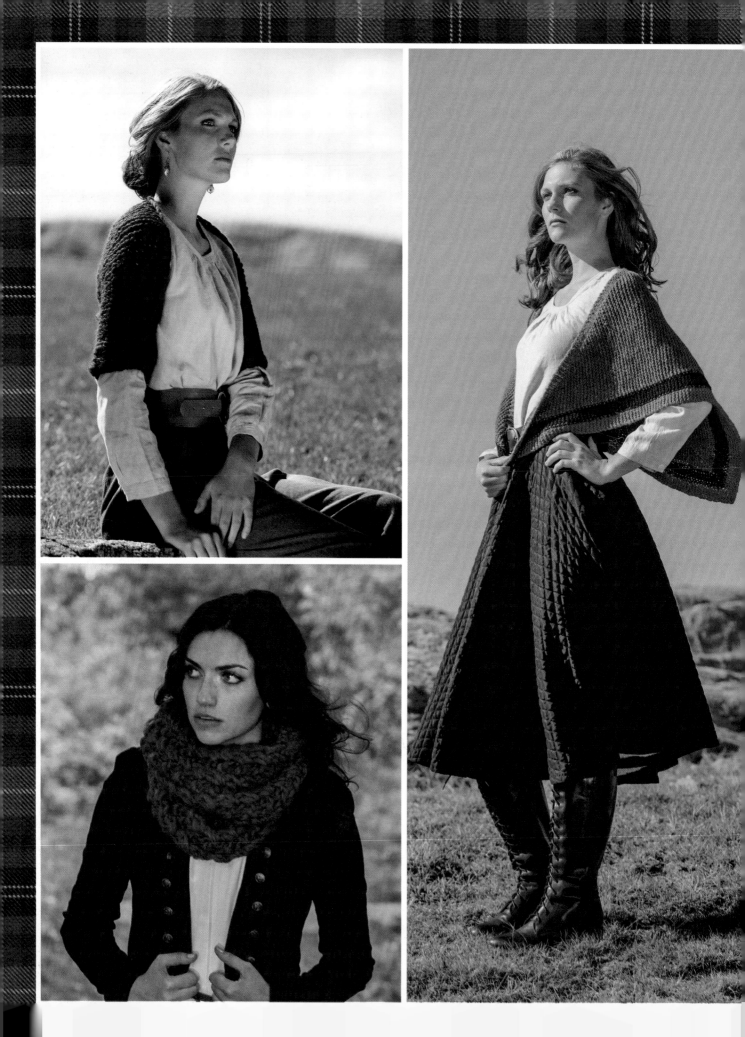

The
PROJECTS

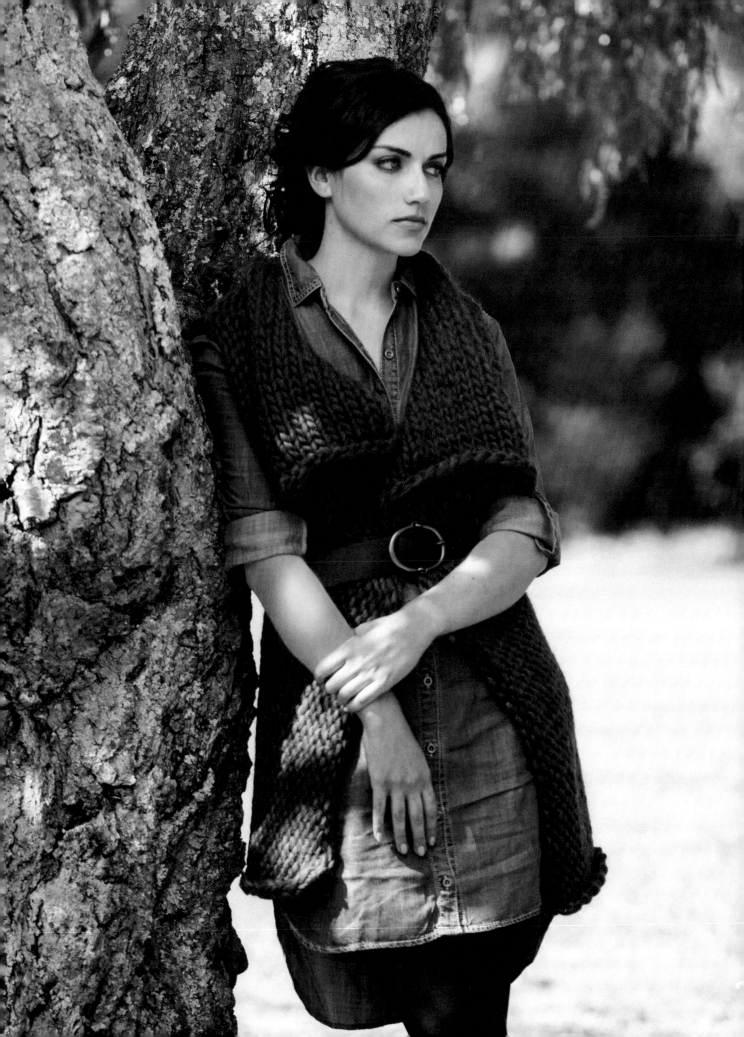

TIME TRAVELER REVERSIBLE VEST

When crossing centuries or just running errands, versatility is key. This unusual wrap can be worn several ways: belted or open, with a shorter collar and a longer vest (as shown) or turned upside down for an over-sized collar.

Designed by Karen Clements

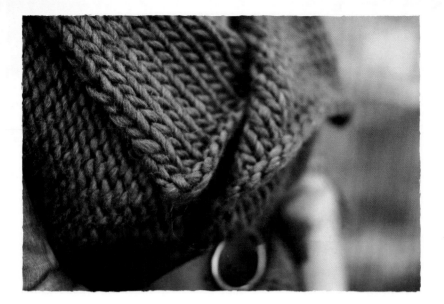

Finished Size

About 16" (40.5 cm) across back and 30" (76 cm) long.

Yarn

Bulky weight (#6 Super Bulky).

Shown here: Cascade Yarns Magnum (100% wool; 123 yd [112.5 m]/8.82 oz [250 g]): #9748 mocha heather, 3 skeins.

Needles

Size U.S. 19 (15 mm): 16" (40 cm) and 24" (60 cm) circular (cir) needles.

Adjust needle size if necessary to obtain the correct gauge.

Notions

Tapestry needle.

Gauge

6 sts and 8 rows = 4" (10 cm) in Rev St st.

STITCH GUIDE

Reverse Stockinette Stitch (Rev St st)

Row 1: (RS) Purl.

Row 2: (WS) Knit.

Rep Rows 1 and 2 for pattern.

Notes

Circular needle is recommended to accommodate large number of sts. Do not join; work back and forth in rows.

This vest is a rectangle worked vertically, but turned and worn horizontally with the purl side on the RS so the collar shows the knit side.

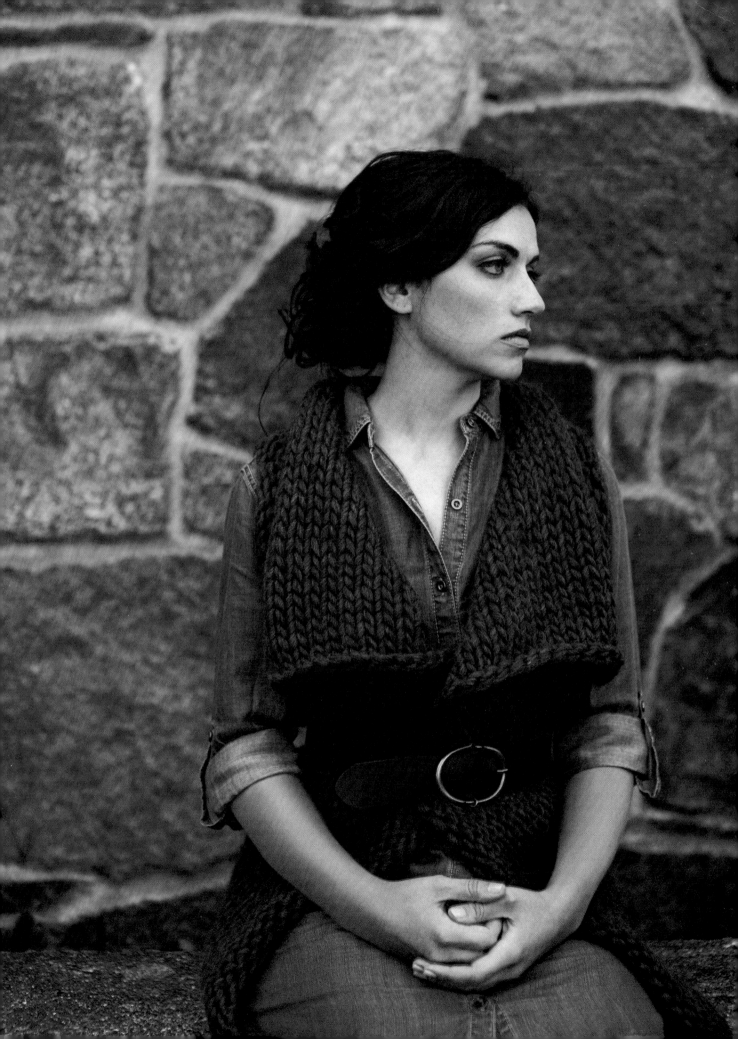

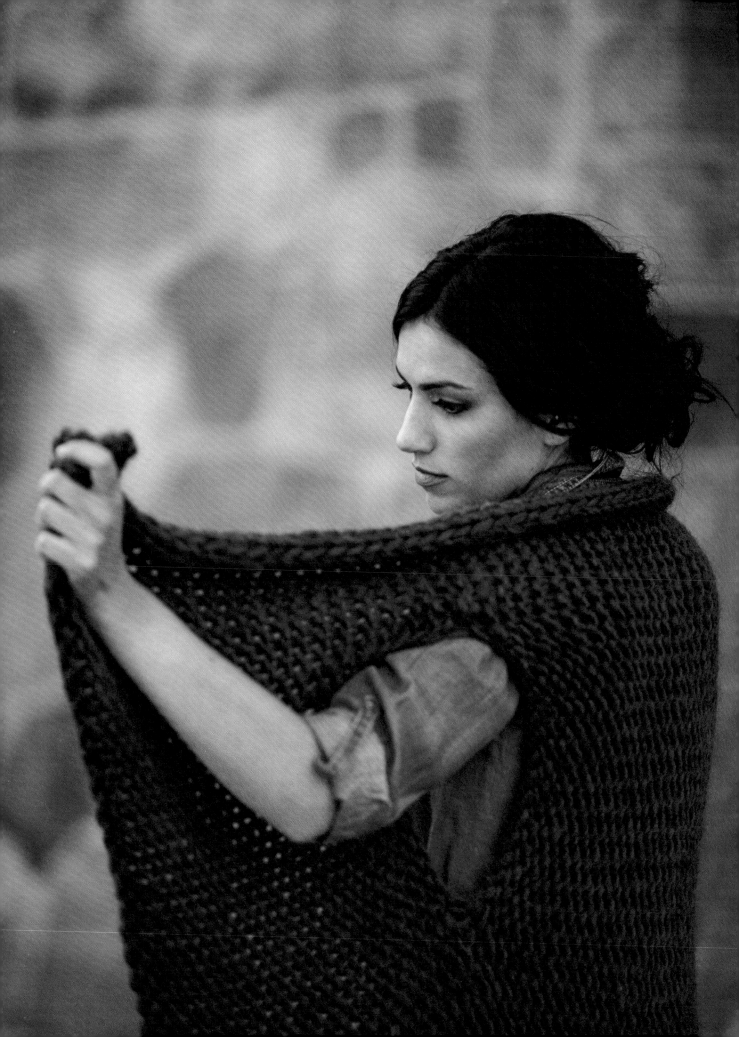

FRONT

With longer cir, CO 45 sts. Do not join; work back and forth in rows.

Beg with a WS row, work in Rev St st (see Stitch Guide) for 25 rows, ending after a WS row.

Shape Armhole

Row 1 (RS): P12, BO 14 sts kwise, p19.

Row 2 (WS): K19, use the backward-loop method (see Glossary) to CO 14, k12.

BACK

Cont to work 30 rows in Rev St st, or until piece meas desired width across shoulders, ending after a WS row.

Shape Armhole

Rep Rows 1 and 2 of previous armhole.

FRONT

Cont to work 25 more rows in Rev St st, ending after a RS row.

BO all sts.

FINISHING

Block piece to measurements.

Armhole Trim

With shorter cir and WS (knit side) facing, beg at lower edge of armhole, pick up and knit 14 sts along first half of armhole, 1 st between CO and BO, 14 sts along rem half of armhole, then 1 st between CO and BO—30 sts. BO all sts kwise.

Rep for second armhole.

Weave in ends.

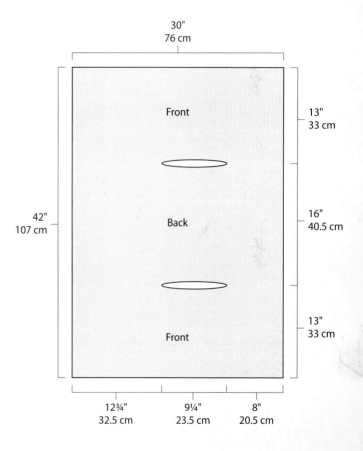

MISTRESS BEAUCHAMP'S CAPELET

Subtle lace details dress up this effortless capelet. A cross between a cowl and a shrug, this wonderful alternative to a jacket warms your shoulders while keeping your hands free.

Designed by Karen Clements

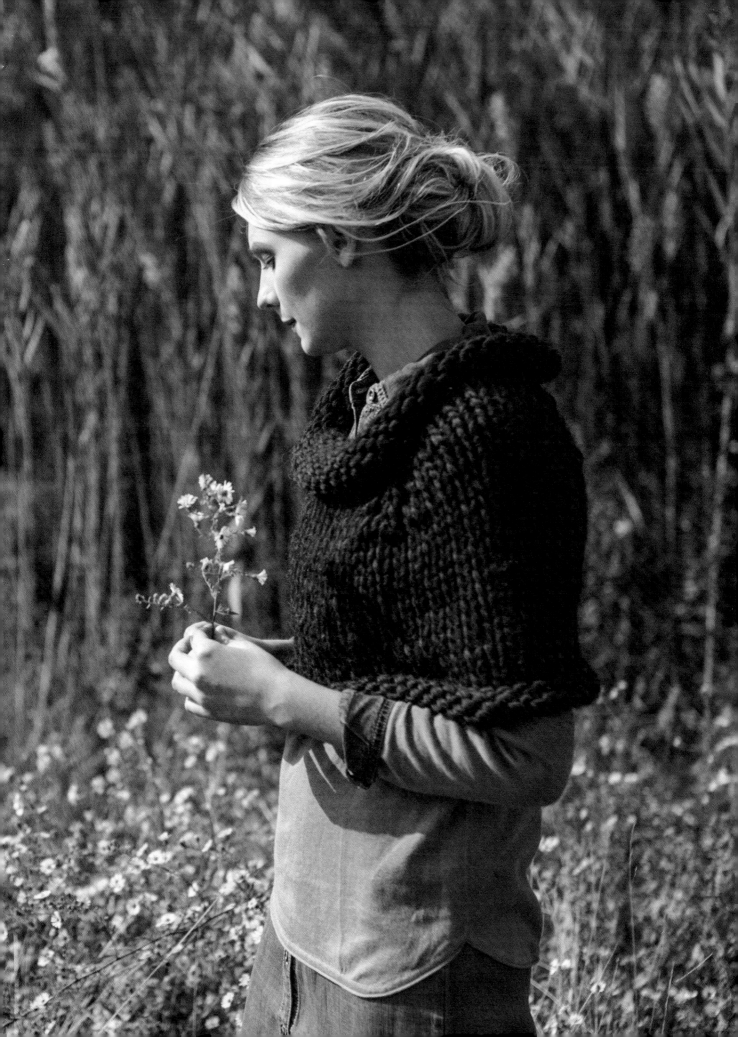

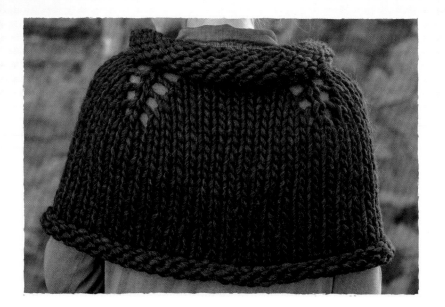

Finished Size

About 34¾ (40, 45¼)" (88.5 [101.5, 115] cm) in body circumference.

About 17 (20, 20)" (43 [51, 51] cm) long.

Capelet shown meas 40" (101.5 cm) in circumference.

Yarn

Bulky weight (#6 Super Bulky).

Shown here: Cascade Yarns Magnum (100% wool; 123 yd [112.5 m]/8.82 oz [250 g]): #0075 charcoal, 2 (2, 2) skeins.

Needles

Size U.S. 19 (15 mm): 24" (60 cm) circular (cir) needle.

Size U.S. 35 (19 mm): straight or cir needle (optional for BO).

Adjust needle sizes if necessary to obtain the correct gauge.

Notions

Stitch markers (m); waste yarn (optional); tapestry needle.

Gauge

6 sts and 8 rnds = 4" (10 cm) in Stockinette st with smaller needles, worked in the rnd.

Notes

Capelet is knit from the top down.

Place different-colored markers for capelet and beg of rnd to easily tell them apart.

Tips are given for adjusting the size of this capelet to fit your body. If adjustments are made, more yarn may be required than what is listed in the yarn requirements.

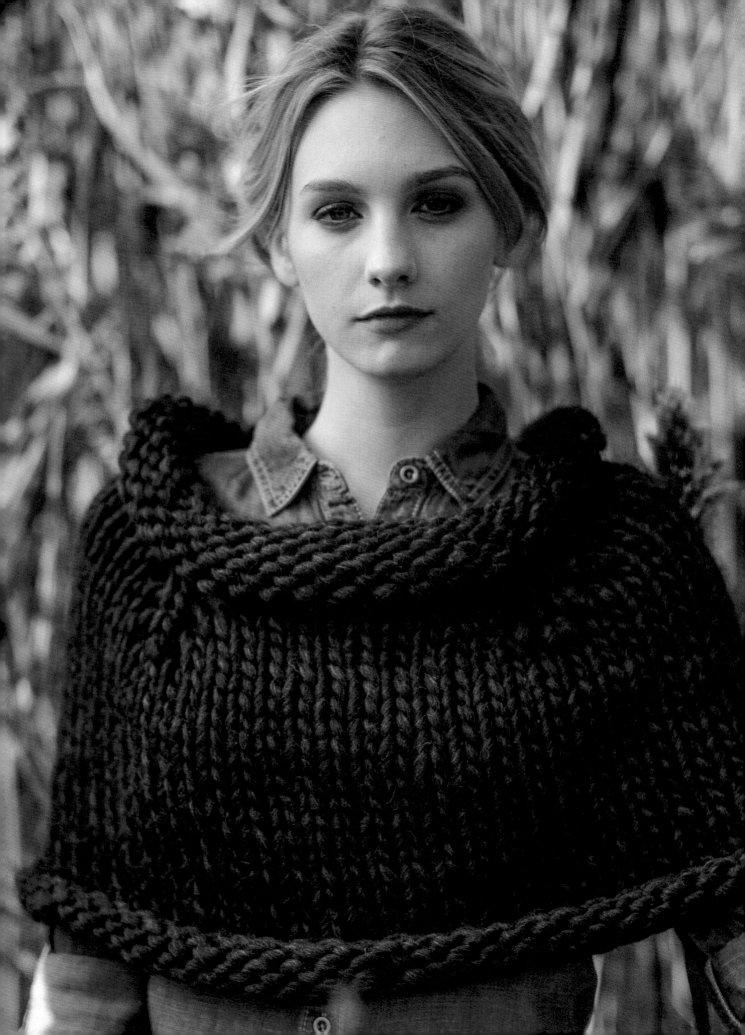

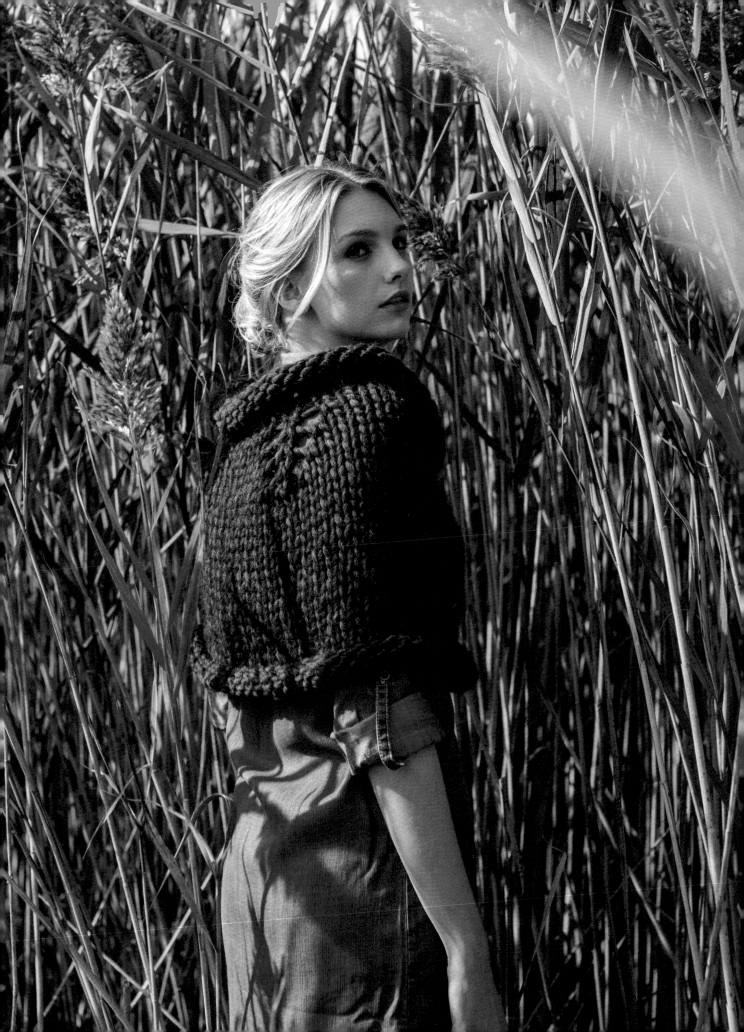

COLLAR

With smaller cir, use the backward-loop method (see Glossary) to CO 44 (44, 52) sts. Pm for beg of rnd and join to work in the rnd, being careful not to twist sts. Marker is placed at the center of the back.

Knit 6 rnds.

Shape Collar

Set-up Rnd: K3 (3, 4), k2tog, k1, pm, k2tog, ★k6 (6, 8), k2tog, k1, pm, k2tog; rep from ★ 2 more times, k3 (3, 4)—36 (36, 44) sts rem.

Knit 1 rnd.

Dec Rnd: ★Knit to 3 sts before m, k2tog, k1, sl m, k2tog; rep from ★ 3 more times, knit to end—28 (28, 36) sts rem.

Knit 2 rnds.

CAPELET

Shape Capelet

Inc Rnd: ★Knit to 1 st before next m, yo, k1, sl m, yo; rep from ★ 3 more times, knit to end—8 sts inc'd.

Knit 1 rnd.

Rep the last 2 rnds 2 (3, 3) more times—52 (60, 68) sts.

Note: If you'd like to make the capelet larger—for example, if you have a larger bust—rep the last 2 rnds once or twice more.

Remove all m except beg-of-rnd m.

Knit 16 (20, 20) rnds.

Note: If a longer capelet is desired, knit 4 more rnds.

Last Inc Rnd: Work as follows, depending on how many sts are on the needle:

For 52 sts: ★K13, M1 (see Glossary); rep from ★ —56 sts.

For 60 sts: ★K15, M1 (see Glossary); rep from ★ —64 sts.

For 68 sts: ★K17, M1 (see Glossary); rep from ★ —72 sts.

For 76 sts: ★K19, M1 (see Glossary); rep from ★ —80 sts.

For 84 sts: ★K21, M1 (see Glossary); rep from ★ —88 sts.

BO all sts loosely or use a #35 needle (optional).

FINISHING

Weave in ends. Block if desired.

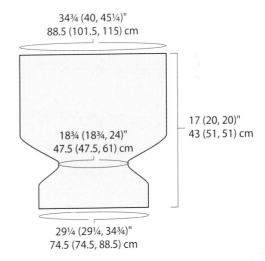

34¾ (40, 45¼)"
88.5 (101.5, 115) cm

18¾ (18¾, 24)"
47.5 (47.5, 61) cm

17 (20, 20)"
43 (51, 51) cm

29¼ (29¼, 34¾)"
74.5 (74.5, 88.5) cm

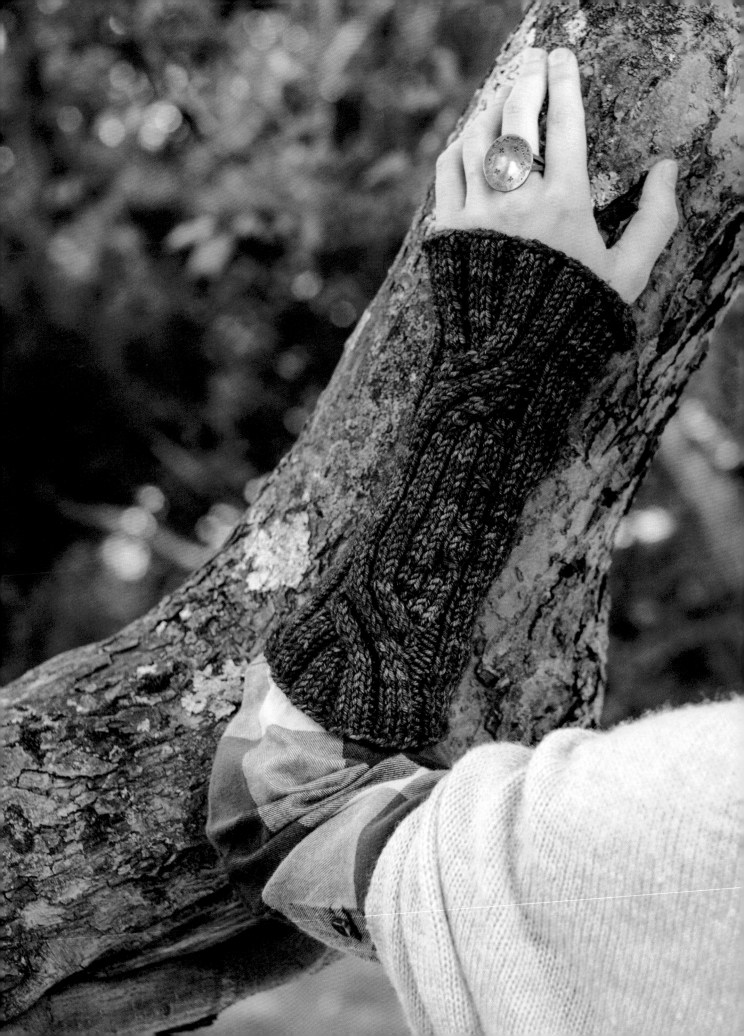

HERB GARDEN GAUNTLETS

An intricate cable panel adds knitting interest to this simple design. They're an elegant accessory, yet practical enough to wear while gathering herbs and flowers.

Designed by Carol Ruhl

Finished Size

About 7¼" (18.5 cm) in circumference and 8¾" (22 cm) long.

Yarn

Worsted weight (#4 Medium).

Shown here: Madelinetosh Tosh Vintage (100% superwash merino; 200 yd [183 m])/3½ oz [100 g]): whiskey barrel, 1 skein.

Needles

Size U.S. 6 (4 mm): set of 4 double-pointed (dpn). *Adjust needle size if necessary to obtain the correct gauge.*

Notions

Stitch marker (m); cable needle (cn); tapestry needle.

Gauge

20 sts and 31 rnds = 4" (10 cm) in Stockinette st worked in the rnd; 24 sts = 2½" (6.5 cm) in Cable Panel.

STITCH GUIDE

3/2/3LPC: Sl 3 sts to cn, hold in front, k3, p2, then k3 from cn.

3/2/3RPC: Sl 5 sts to cn, hold in back, k3, then p2, k3 from cn.

1/2LC: Sl 1 st to cn, hold in front, k2, then k1 from cn.

Cable Panel: (panel of 24 sts)

See also chart on page 27.

Rnd 1: K1, p2, k3, p2, 3/2/3LPC (see above), p2, k3, p2, k1.

Rnds 2, 4, 6, and 8: K1, p2, [k3, p2] 4 times, k1.

Rnd 3: K1, p2, 3/2/3LPC, p2, 3/2/3LPC, p2, k1.

Rnd 5: Rep Rnd 1.

Rnd 7: Rep Rnd 3.

Rnd 9: Rep Rnd 1.

Rnds 10–16: Rep Rnd 2.

Rnd 17: K1, p2, 1/2LC (see above), [p2, k3] 3 times, p2, k1.

Rnds 18–22: Rep Rnd 2.

Rnds 23–34: Rep Rnds 17–22 twice.

Rnd 35: Rep Rnd 17.

Rnd 36: K1, p2, k3, p2, 3/2/3RPC (see above), p2, k3, p2, k1.

Rnds 37, 39, 41, and 43: Rep Rnd 2.

Rnd 38: K1, p2, 3/2/3RPC, p2, 3/2/3RPC, p2, k1.

Rnd 40: Rep Rnd 36.

Rnd 42: Rep Rnd 38.

Rnd 44: Rep Rnd 36.

Rnds 45–49: Rep Rnd 2.

Work Rnds 1–49 for patt.

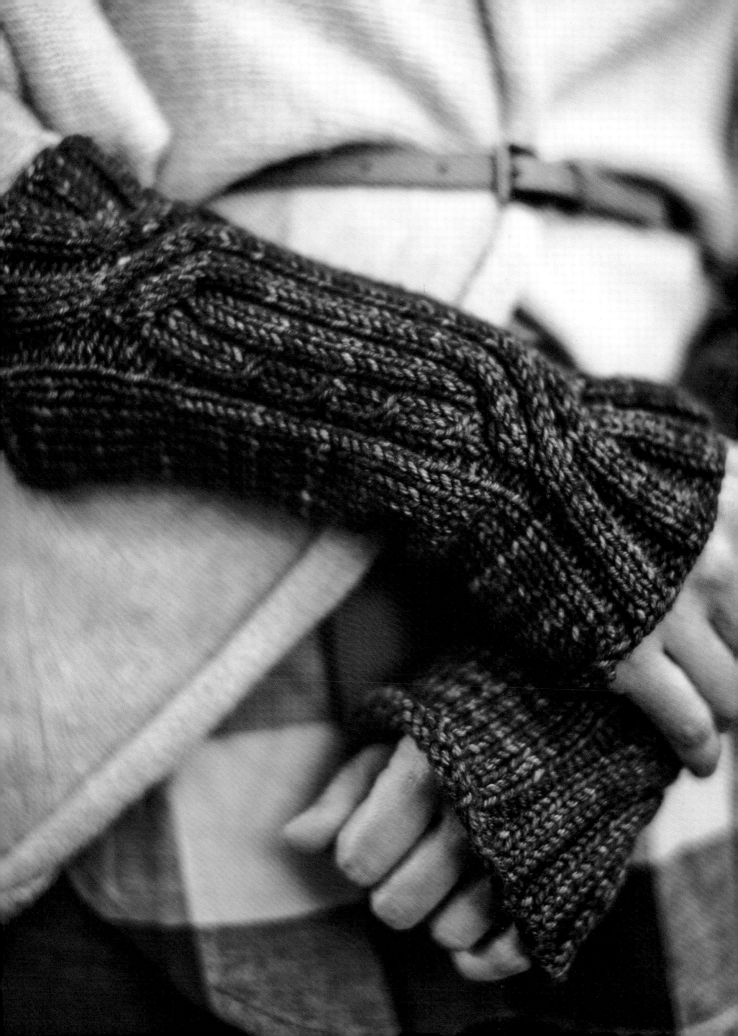

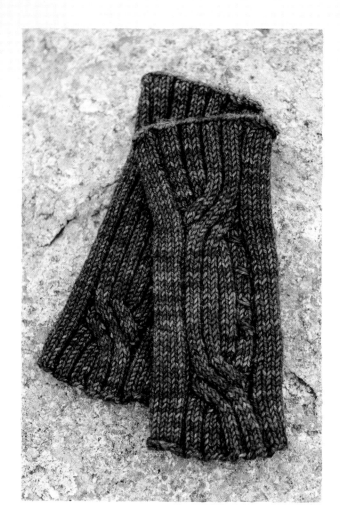

GAUNTLET (Make 2)

CO 48 sts. Divide between 3 dpn as follows: 24 sts on needle 1; 12 sts each on needles 2 and 3. Pm for beg of rnd and join to work in the rnd, being careful not to twist sts.

Est Rib Patt: On needle 1: k1, p2, [k3, p2] 4 times, k1; on needles 2 and 3: knit.

Work as est for 9 more rnds.

Est Cable Patt: On needle 1: work Cable Panel (see Stitch Guide or chart); on needles 2 and 3: knit.

Cont working as est until Rnds 1–49 of Cable Panel are completed.

Inc Rnd: On needle 1: k1, [p2, k3] twice, p1, M1 (see Glossary), p1, k3, p1, M1, p1, k3, p2, k1; on needles 2 and 3: knit—50 sts.

Est Rib Patt: On needle 1: k1, [p2, k3] twice, [p3, k3] twice, p2, k1; on needles 2 and 3: knit.

Work as est for 6 more rnds.

BO all sts in patt.

FINISHING

Weave in ends. Block to measurements.

CABLE PANEL CHART

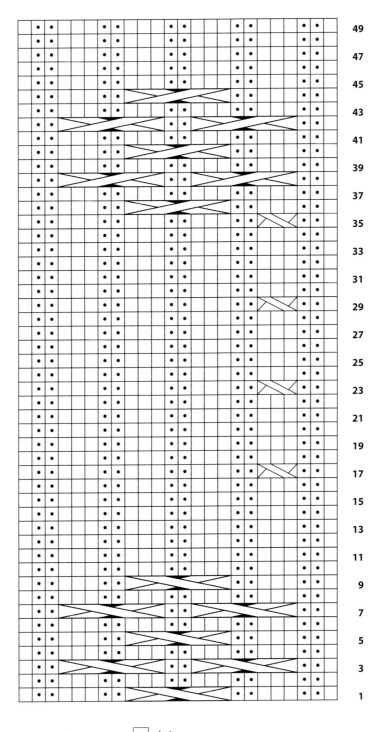

49
47
45
43
41
39
37
35
33
31
29
27
25
23
21
19
17
15
13
11
9
7
5
3
1

☐ knit

• purl

3/2/3LPC (see Stitch Guide)

3/2/3RPC (see Stitch Guide)

1/2LC (see Stitch Guide)

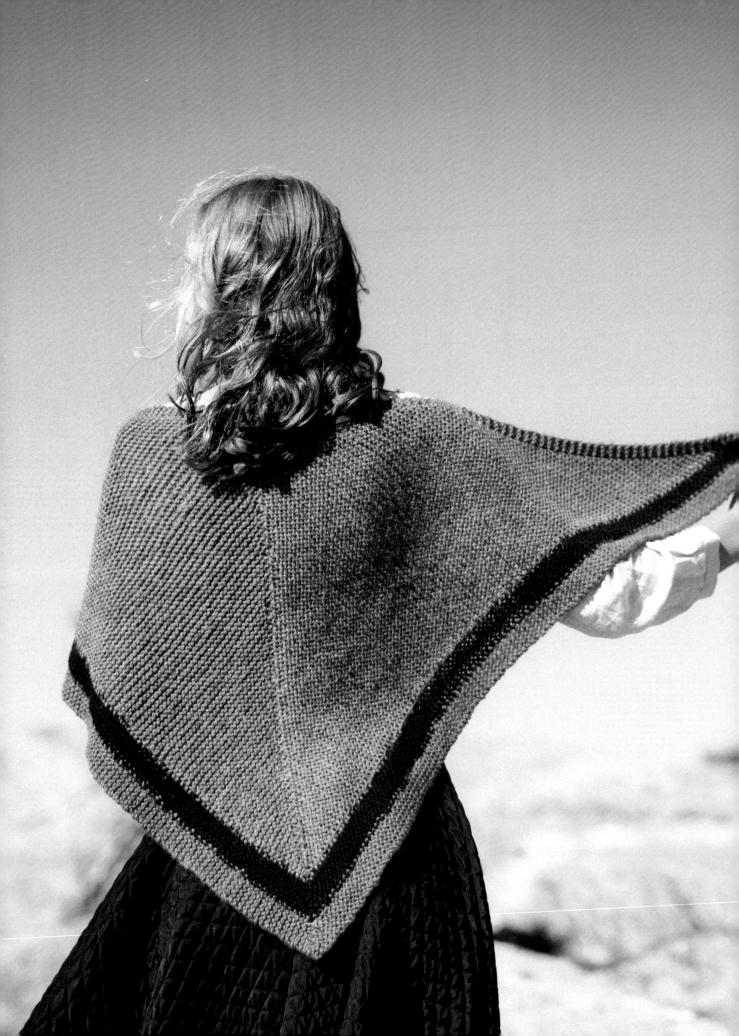

RENT COLLECTION SHAWL

Based on the lovely shawl Claire wears on her trip with the MacKenzies, this design features intarsia stripes for an interesting knit. Use a kilt pin, other decorative brooch, or shawl pin to close at the front edge.

Designed by Jennifer Jackson

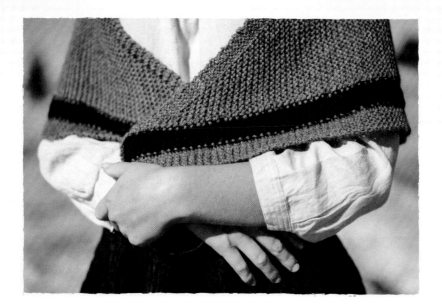

Finished Size

About 44" (112 cm) wide and 24" (61 cm) deep.

Yarn

Worsted weight (#4 Medium).

Shown here: Lion Brand Fishermen's Wool (100% wool; 465 yd [425 m]/8 oz [227 g]): #125 brown heather (A), 1 skein.

Patons Classic Wool Worsted (100% wool; 210 yd [192 m]/3½ oz [100 g]): #208 jade heather (B) and #226 black (C), 1 skein each.

Needles

Size U.S. 9 (5.5 mm): straight needles.

Adjust needle size if necessary to obtain the correct gauge.

Notions

Stitch markers (m); tapestry needle.

Gauge

17½ sts and 30 rows = 4" (10 cm) in garter st.

Notes

When working intarsia with multiple balls of yarn attached to the work, there will be some tangling and untangling of yarn. If you wish to minimize the time spent untangling, colors B and C may be cut into lengths of about 1–2 yards. Join new lengths of colors B and C when necessary.

When you weave in the loose ends, you will tighten up the stripes in the cast-on and bind-off rows.

When doing intarsia, it's important to twist the yarn between every color change so you catch the yarn and don't create a hole. When doing this in garter st (in which every row is knit), the new color yarn will be in the front of the work. Pull that color to the back of the work, twist it and catch it before proceeding to knit with the new color.

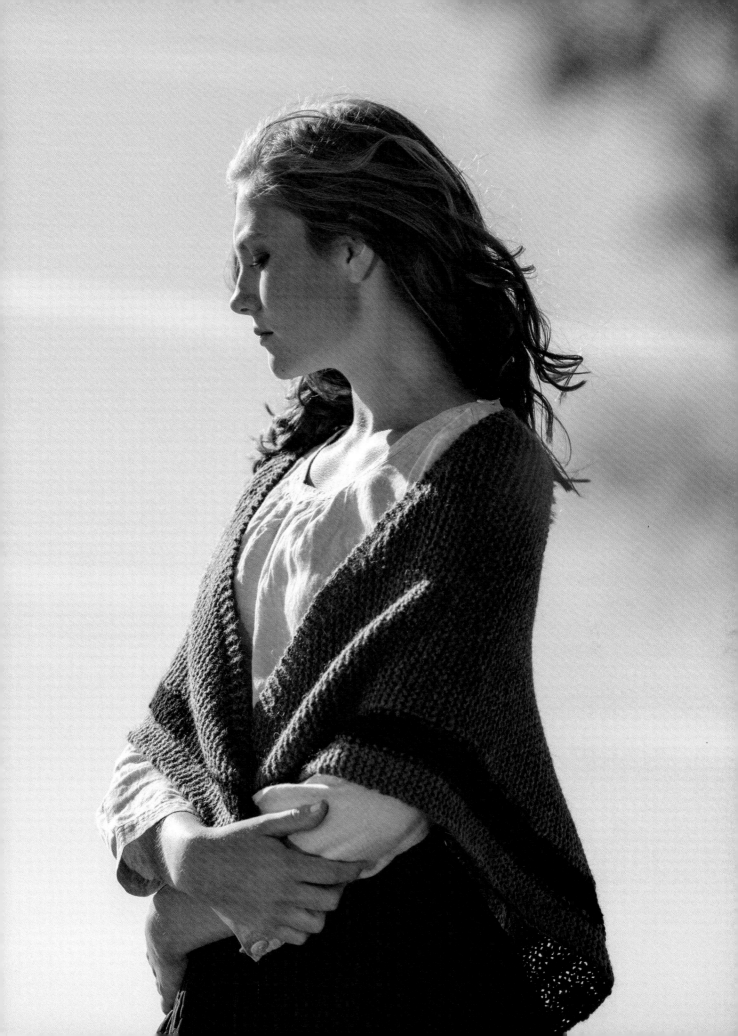

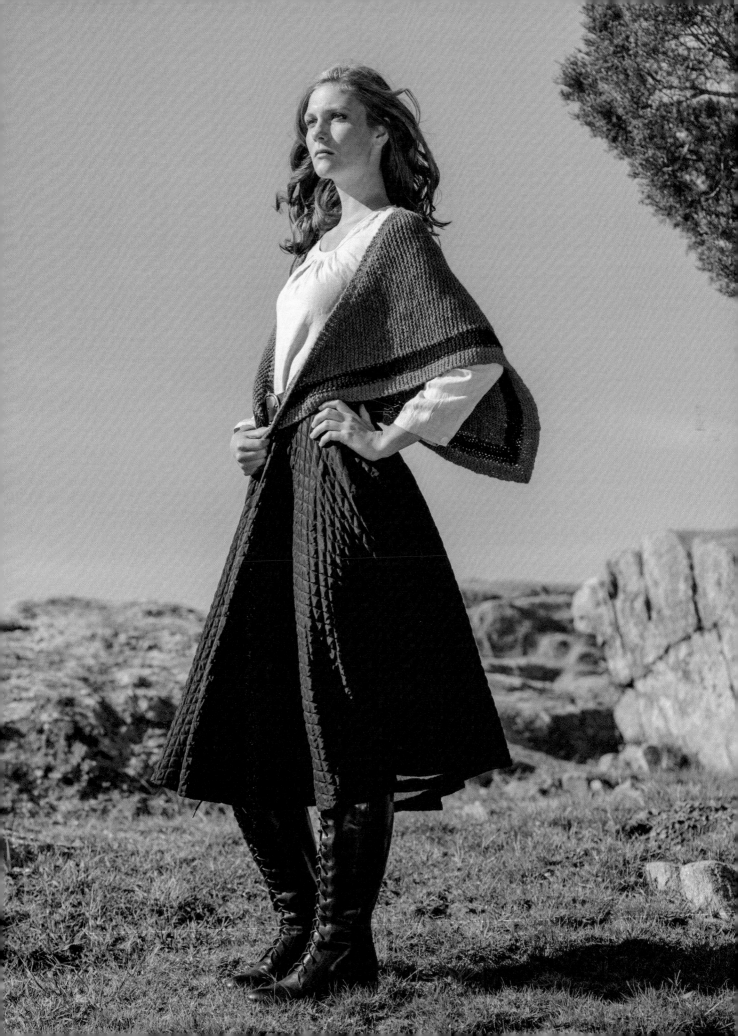

SHAWL

With B: CO 5 sts, pm; with C: CO 4 sts, pm; with A: CO 1 st—10 sts.

Est Patt (RS): Work in intarsia as follows: with A: knit to m, sl m; with C: k4, sl m; with B: knit to end.

Next Row and all WS rows: With B: k5, sl m; with C: k4, sl m; with A: knit to end.

Increase Rows

Inc Row 1 (RS): With A: k1f&b, sl m, knit to end in colors as est—1 st inc'd.

Knit 1 WS row even.

Inc Row 2 (RS): Knit to 1 st before m, k1f&b, sl m, knit to end in colors as est—1 st inc'd.

Rep the last 2 rows 2 more times—14 sts.

Knit 1 WS row even.

Inc Row 3 (RS): K3, k1f&b, knit to m, sl m, knit to end in colors as est—1 st inc'd.

Rep the last 2 rows 55 more times—70 sts.

Short-Rows (see Glossary)
Short-Row 1 (WS): Working in colors as est, k64, sl 1 pwise wyb, wrap next st and turn so RS is facing; (RS) knit to end in colors as est.

Short-Row 2 (WS): Working in colors as est, knit to 2 sts before wrap from previous row, sl 1 st pwise wyb, wrap next st and turn so RS is facing; (RS) knit to end in colors as est.

Rep Short-Row 2 sixty-three more times, until only 1 st is worked between beg of WS row and wrap.

Conceal the Short-Rows

Short-Row 3 (WS): Working in colors as est, knit to wrapped st, knit wrap together with the st it wraps, turn so RS is facing; (RS) knit to end in colors as est.

Rep Short-Row 3 sixty-three more times, until all wraps except 1 have been knit together with the sts they wrap.

Next Row (WS): Working in colors as est, knit to final wrapped st, knit wrap together with the st it wraps, knit to end.

Decrease Rows

Dec Row 1 (RS): K3, ssk, knit to end in colors as est—1 st dec'd.

Work 1 WS row even.

Rep the last 2 rows 56 more times—13 sts rem.

Dec Row 2 (RS): Knit to 2 sts before first m, ssk, knit to end in colors as est—1 st dec'd.

Knit 1 WS row even.

Rep the last 2 rows once more—11 sts rem.

Dec Row 3 (RS): Ssk, knit to end—10 sts rem.

BO all sts in colors as est.

FINISHING

Weave in ends. Block to measurements.

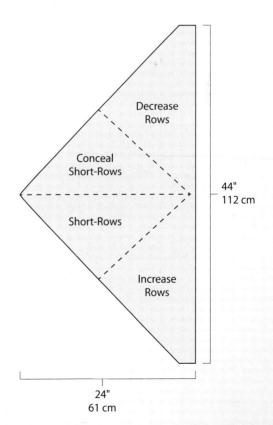

THE GATHERING INFINITY SCARF

A twisted rib stitch gives this easy cowl lots of gorgeous texture to pair it with your clan's tartan or your favorite jeans. Wear it long or doubled for added warmth.

Designed by Karen Clements

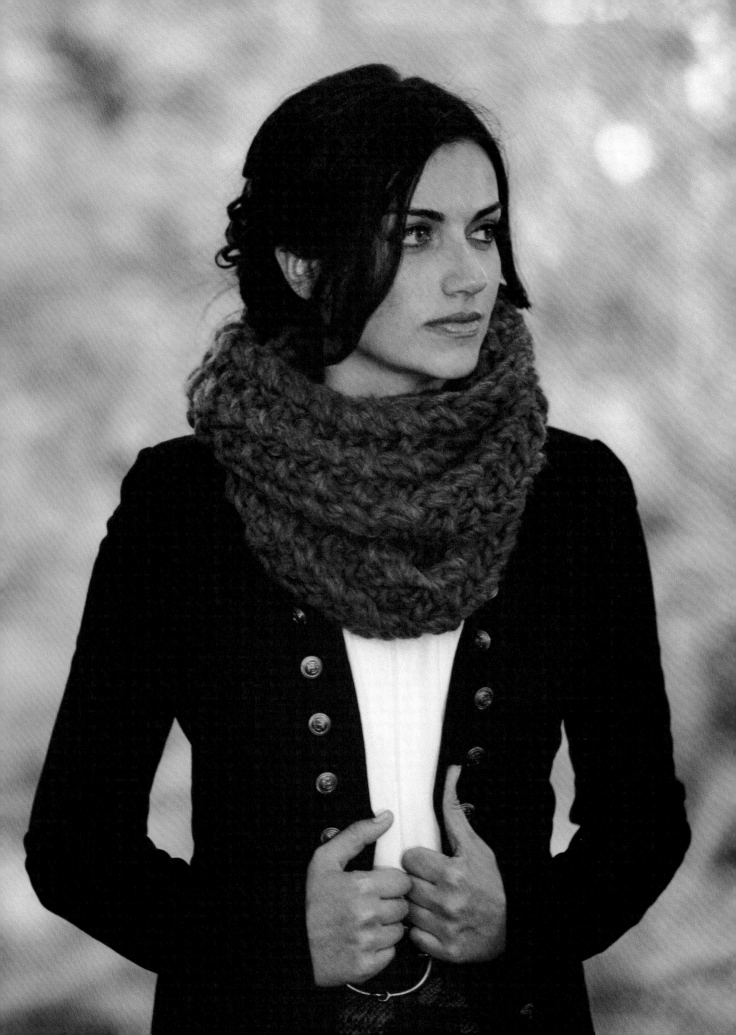

Finished Size

About 7½" (19 cm) wide by 24 (50)" (61 [127] cm) in circumference.

Cowl shown meas 50" (127 cm) in circumference.

Yarn

Bulky weight (#6 Super Bulky).

Shown here: Cascade Yarns Magnum (100% wool; 123 yd [112.5 m]/8.82 oz [250 g]): #8400 charcoal, 1 (1) skein.

Needles

Size U.S. 19 (15 mm): straight needles.

Adjust needle size if necessary to obtain the correct gauge.

Notions

Tapestry needle.

Gauge

7 sts and 7 rows = 4" (10 cm) in Twisted Rib Pattern.

Note

If making the shorter cowl, you can make 2 cowls with 1 skein of yarn.

COWL

CO 13 sts.

Work Rows 1 and 2 of Twisted Rib Patt (see Stitch Guide or chart) until the cowl meas 24 (50)" [61 (137) cm], ending after Row 2 of patt.

BO all sts pwise.

FINISHING

Block piece to measurements. Sew CO and BO edges together.

Weave in ends.

STITCH GUIDE

RT: Skip the first st, knit the second st, then knit the first st and let both sts slip off the needle.

Twisted Rib Pattern: (multiple of 3 sts + 4)

See also chart.

Row 1 (WS): Sl 1 st pwise wyf, purl to end.

Row 2 (RS): Sl 1 st pwise wyb, *RT, p1 (see above); rep from * to last 3 sts, RT, k1.

Rep Rows 1 and 2 for patt.

TWISTED RIB CHART

	knit on RS, purl on WS
·	purl on RS, knit on WS
⤱	sl 1 st pwise wyf on WS
v	sl 1 st pwise wyb on RS
⧄	RT (see Stitch Guide)
	pattern repeat

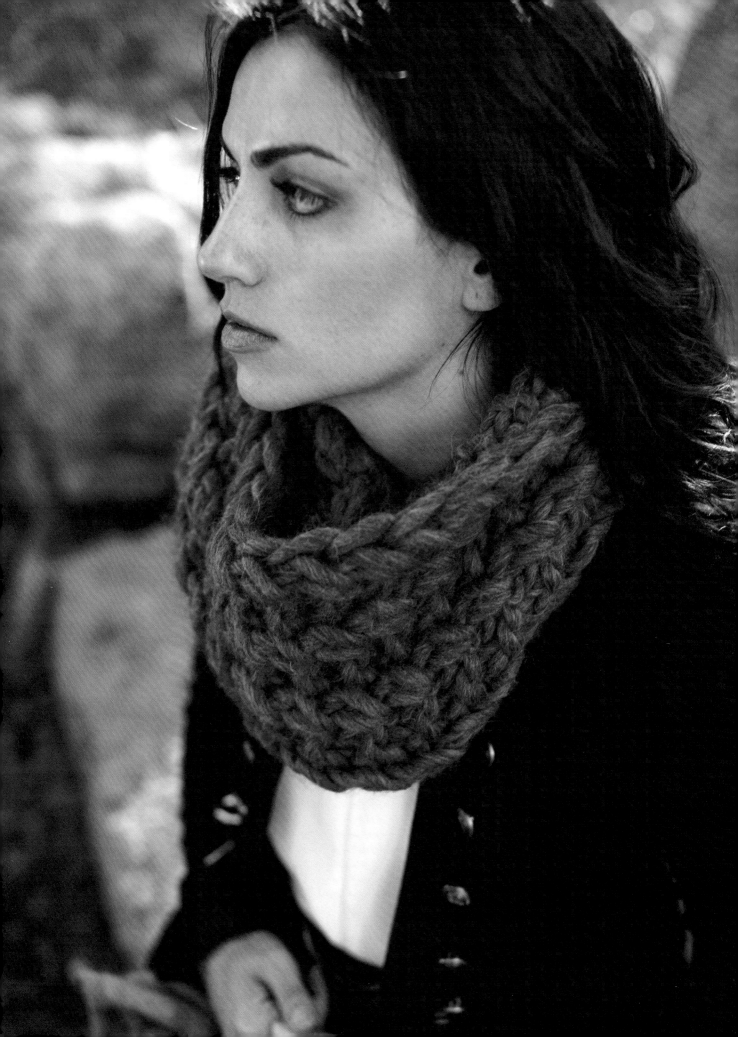

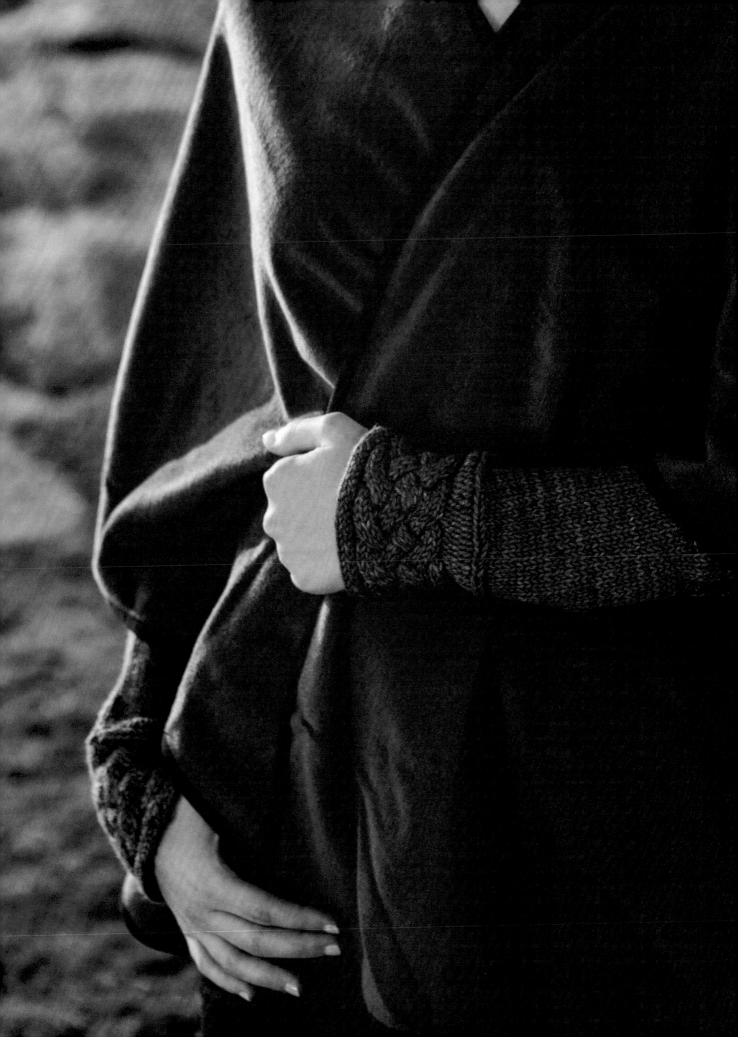

HEALER'S HANDS GAUNTLETS

It's important to keep your hands warm but your fingers free when you're mixing up potions in a damp apothecary. The intricate cabled cuffs are worked side to side and seamed; then stitches are picked up to create the wrist coverings.

Designed by Kristen Brooks

Finished Size

About 8" (20.5 cm) in circumference and 10¾"
(27.5 cm) long.

Yarn

Worsted weight (#4 Medium).

Shown here: Western Sky Knits Magnolia Worsted
(80% superwash merino, 10% cashmere, 10%
nylon; 200 yd [182 m]/4 oz [113 g]): charcoal,
1 skein.

Needles

Size U.S. 8 (5 mm): straight needles and set of 4 or
5 double-pointed (dpn).

Size U.S. 6 (4 mm): set of 4 or 5 dpn.

*Adjust needle sizes if necessary to obtain the correct
gauge.*

Notions

Waste yarn for provisional cast-on; stitch marker
(m); cable needle (cn); tapestry needle.

Gauge

20 sts and 24 rnds = 4" (10 cm) in Stockinette
st worked in the rnd with larger needle; 27 sts =
4¼" (11 cm) in Cable Panel worked in rows with
larger needle.

Notes

The cuff is worked first, knit side to side and
formed into a ring by joining the CO and BO
edges together. Then the sts for the arm are picked
up along one selvedge edge of the cuff.

STITCH GUIDE

3/3LC: Sl 3 sts to cn and hold to front, k3, k3
from cn.

3/3RC: Sl 3 sts to cn and hold to back, k3, k3
from cn.

Cable Panel: (panel of 27 sts)

See also chart.

Row 1 (RS): K2, p4, k15, p4, k2.

Row 2 and all WS rows: P2, k4, p15, k4, p2.

Row 3: K2, p4, k3, 3/3LC twice, p4, k2.

Row 5: K2, p4, k15, p4, k2.

Row 7: K2, p4, 3/3RC twice, k3, p4, k2.

Row 8: Rep Row 2.

Rep Rows 1–8 for patt.

K4, P4 Rib: (multiple of 8 sts)

Rnd 1: ★K4, p4; rep from ★.

Rep Rnd 1 for patt.

MITT (Make 2)

Cuff

Use straight needles and provisional method (see Glossary) to CO 27 sts.

Work Rows 1–8 of Cable Panel 7 times.

Carefully remove the waste yarn from the provisional cast-on and place 27 sts onto straight needle. Hold needles parallel with RS's facing together and use a dpn and the three-needle method (see Glossary) to join the sts from each needle together.

Arm

With RS of cuff facing, use larger dpn to pick up and knit (see Glossary) 40 sts evenly around 1 selvedge edge of the cuff. (*Note: Be careful to pick up only the first knit st and leave the V of the second knit st on the edge to show.*) Pm for beg of rnd.

Work in St st (knit all sts, every rnd) until piece meas 5" (12.5 cm) from pick-up rnd.

Ribbing

Change to smaller dpn.

Work in K4, P4 Rib (see Stitch Guide) for 1½" (5 cm).

BO all sts loosely. Jeny's Surprisingly Stretchy Bind-Off (see Glossary) is recommended.

FINISHING

Weave in ends. Block to measurements.

CABLE PANEL CHART

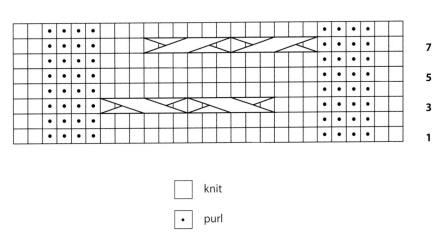

	knit
•	purl

3/3RC (see Stitch Guide)

3/3LC (see Stitch Guide)

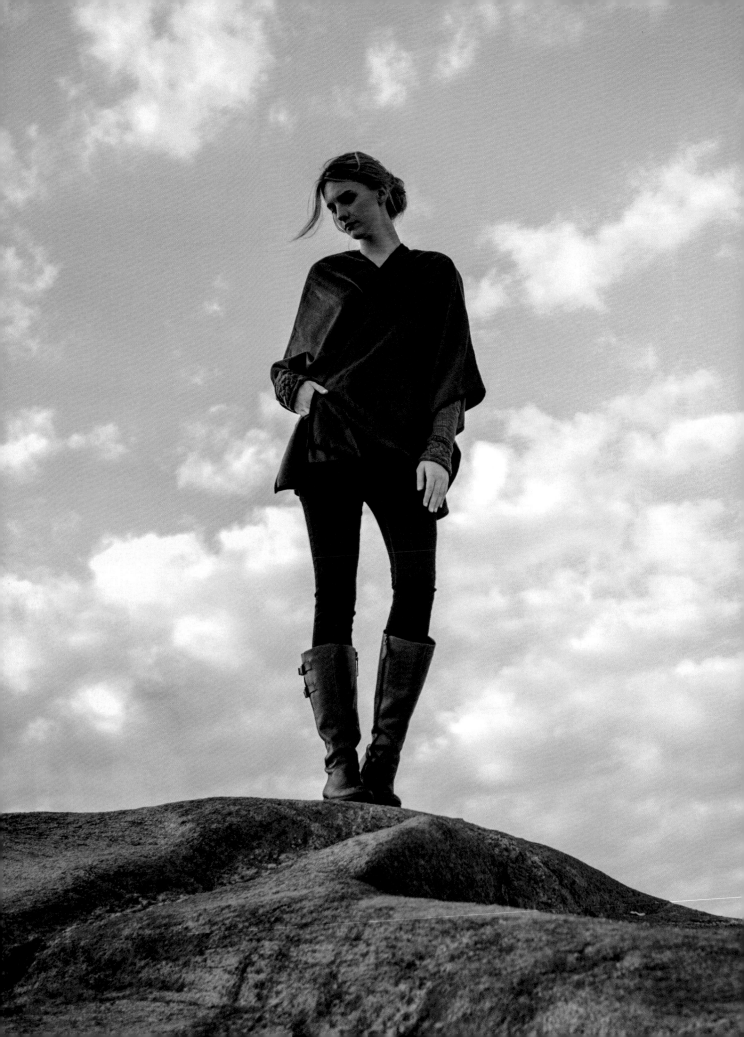

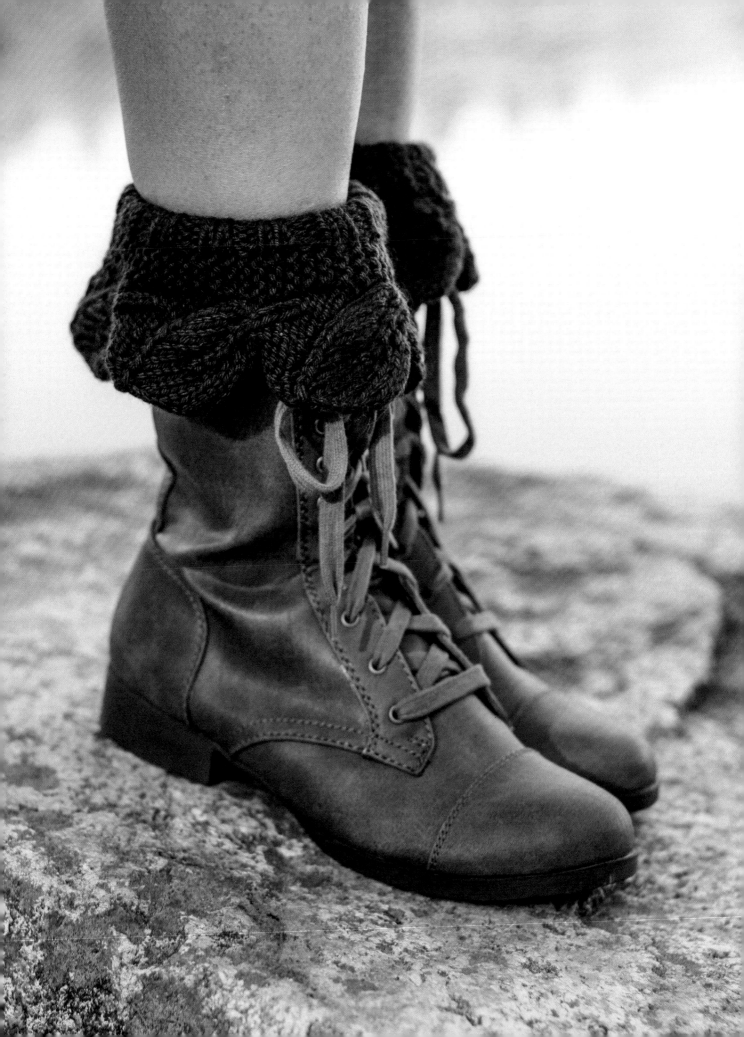

FALLING LEAVES BOOT CUFFS

Cozy boot toppers keep you warm on chilly autumn walks. The pretty leaf motif will turn even the plainest boots into showstoppers.

Designed by Fiona Hamilton-MacLaren

Finished Size

About 11 (14½, 17¼, 19¾)" (28 [37, 44, 50] cm) in maximum calf circumference.

Sample shown in size 17¼" (44 cm).

Yarn

Worsted weight (#4 Medium).

Shown here: Berroco Vintage (52% acrylic, 40% wool, 8% nylon; 217 yd [198 m]/3½ oz [100 g]): #5182 black currant, 1 skein.

Needles

Size U.S. 6 (4 mm): one set of 4 or 5 double-pointed (dpn).

Adjust needle size if necessary to obtain the correct gauge.

Notions

Tapestry needle; stitch marker (m).

Gauge

36 sts and 28 rows = 4" (10 cm) in unstretched K2, P2 Rib.

Note: *Ribbing will stretch to about 13 sts over 4" [10 cm] very stretched.*

Notes

The ribbed section of the cuffs can be as long as you like. To use all the yarn, divide the yarn into 2 equal-size balls before beginning, then work the ribbing until you have just enough yarn remaining for the BO.

When working the 5 BO sts on Row 18 of the Falling Leaves Patt, include the st from the p2tog in the first BO st.

STITCH GUIDE

Falling Leaves Pattern: (begins and ends as a panel of 8 sts)

See also chart on page 49.

Row 1 (RS): K5, yo, k1, yo, k2—10 sts.

Row 2: P6, k1f&b, k3—11 sts.

Row 3: K4, p1, k2, yo, k1, yo, k3—13 sts.

Row 4: P8, k1f&b, k4—14 sts.

Row 5: K4, p2, k3, yo, k1, yo, k4—16 sts.

Row 6: P10, k1f&b, k5—17 sts.

Row 7: K4, p3, k4, yo, k1, yo, k5—19 sts.

Row 8: P12, k1f&b, k6—20 sts.

Row 9: K4, p4, ssk, k7, k2tog, k1—18 sts.

Row 10: P10, k1f&b, k7—19 sts.

Row 11: K4, p5, ssk, k5, k2tog, k1—17 sts.

Row 12: P8, k1f&b, k2, p1, k5—18 sts.

Row 13: K4, p1, k1, p4, ssk, k3, k2tog, k1—16 sts.

Row 14: P6, k1f&b, k3, p1, k5—17 sts.

Row 15: K4, p1, k1, p5, ssk, k1, k2tog, k1—15 sts.

Row 16: P4, k1f&b, k4, p1, k5—16 sts.

Row 17: K4, p1, k1, p6, sk2p (see Glossary), k1—14 sts.

Row 18: P2tog, BO 5 sts, p3, k4—8 sts.

Rep Rows 1–18 for patt.

K2, P2 Rib: (multiple of 4 sts)

Rnd 1: ★K2, p2; rep from ★.

Rep Rnd 1 for patt.

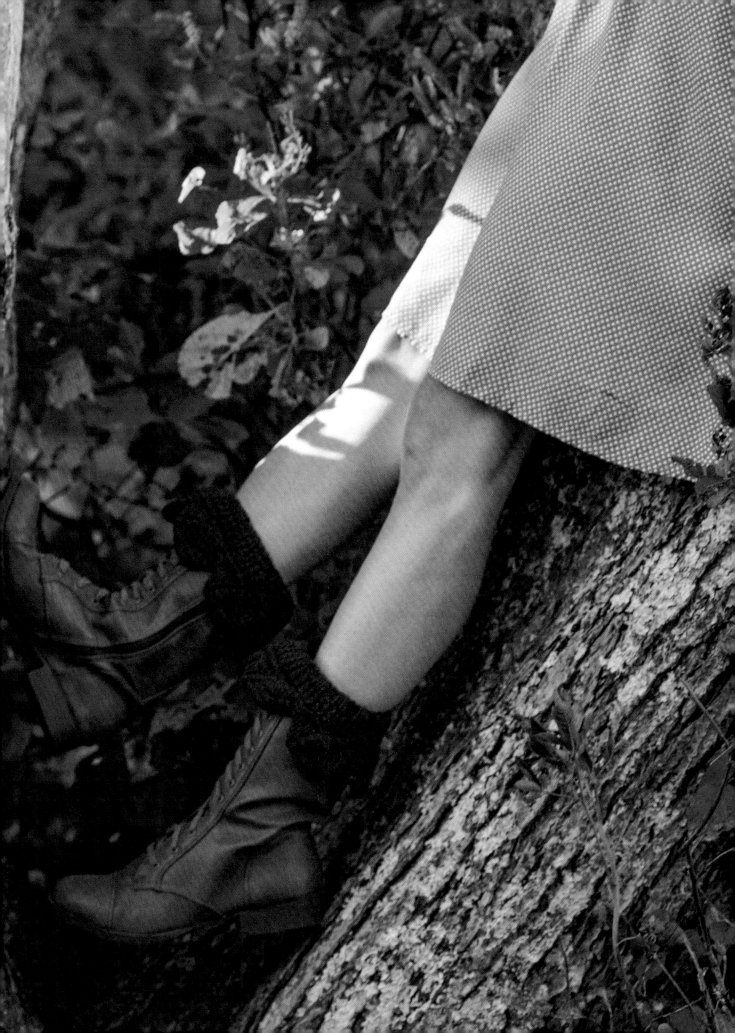

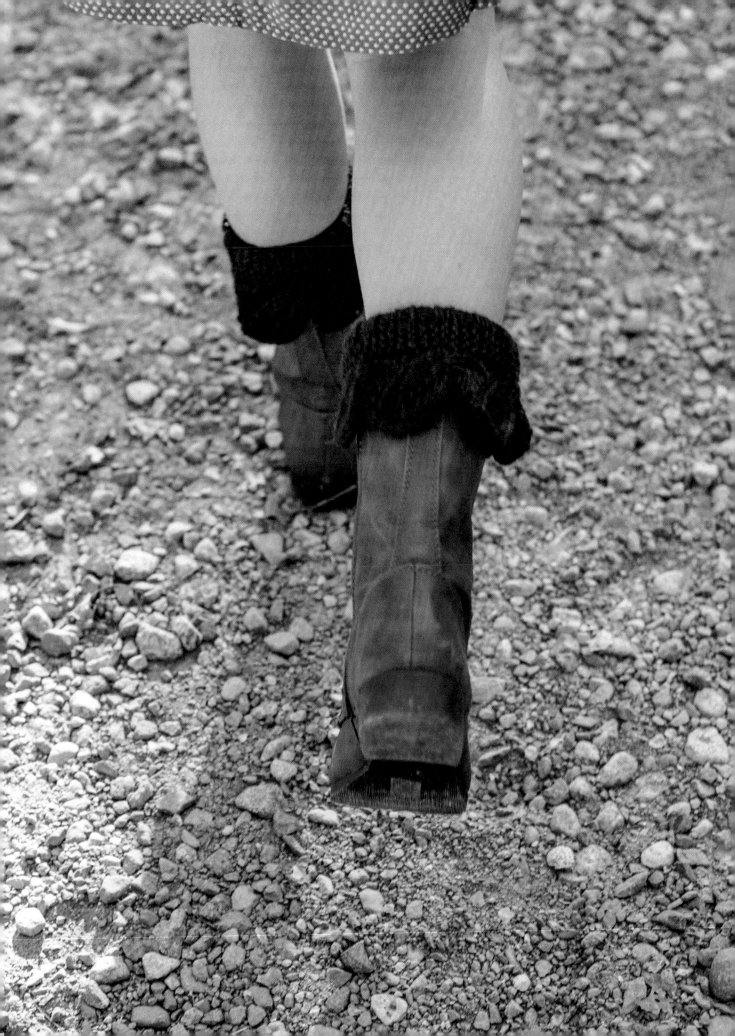

BOOT CUFF (Make 2)

CO 8 sts.

Leaf Edging

Work Rows 1–18 of Falling Leaves Patt (see Stitch Guide or chart) 4 (5, 6, 7) times.

BO all sts.

Sew CO edge to BO edge.

Ribbing

With dpn and RS facing, beg at seam, pick up and knit (see Glossary) 36 (48, 56, 64) sts around the garter st edge of leaf edging.

Work in K2, P2 Rib (see Stitch Guide) until ribbing meas 4" (10 cm) or is your desired length (see Notes).

BO loosely in ribbing.

FINISHING

Weave in ends. Block lightly to measurements.

To wear, turn cuffs inside out, place the ribbing into the boot, then fold leaf edging over to the outside.

FALLING LEAVES CHART

	Symbol legend
	knit on RS, purl on WS
•	purl on RS, knit on WS
o	yo
	k1f&b
\	ssk
/	k2tog
	sk2p
	p2tog
	BO
	no stitch

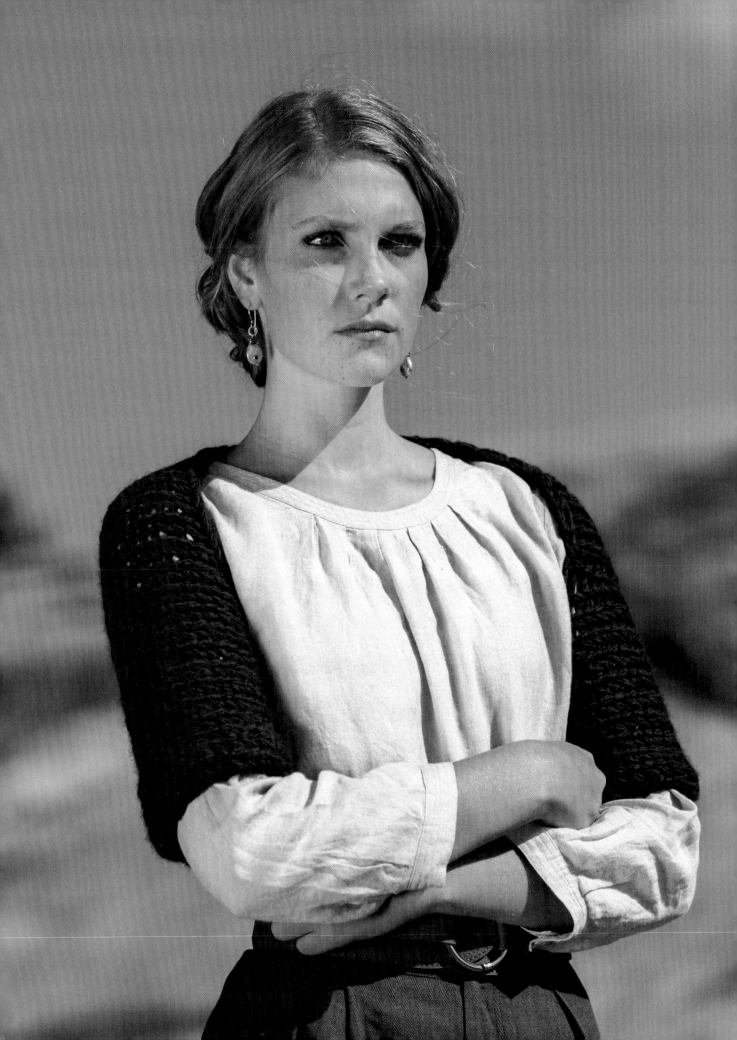

LALLYBROCH SHRUG

This chic and simple shrug is designed to be knit for a custom fit. Just cast on, knit until it's the right size for your arms, then seam the arms. Wear it over a dress or blouse to keep warm when Highland winds blow.

Designed by Karen Clements

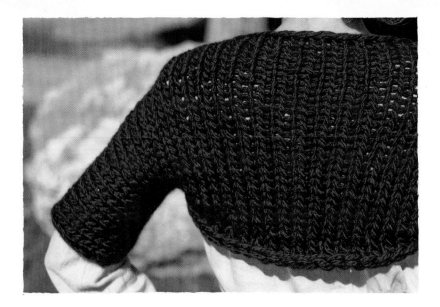

Finished Size

About 32" (82.5 cm) wide.

Yarn

Bulky weight (#6 Super Bulky).

Shown here: Illimani Cadena l (71.5% baby alpaca, 28.5% merino; 49 yd [45 m]/3½ oz [100 g]): #3083 burgundy, 3 skeins.

Needles

Size U.S. 19 (15 mm): two 24" (80 cm) circulars (cir).

Adjust needle size if necessary to obtain the correct gauge.

Notions

Waste yarn (for provisional cast-on); tapestry needle.

Gauge

6 sts and 10 rows = 4" (10 cm) in Stockinette st.

Notes

Circular needle is used to accommodate large number of sts. Do not join; work back and forth in rows.

This piece is worked until it can circle your upper arms. The sample shown measures 10" (25.5 cm) around the upper arms. More or less yarn may be needed if your measurements differ from the sample.

For longer sleeves, CO extra sts and on Short-Row 1 work the first WS row to the center plus 2 more sts.

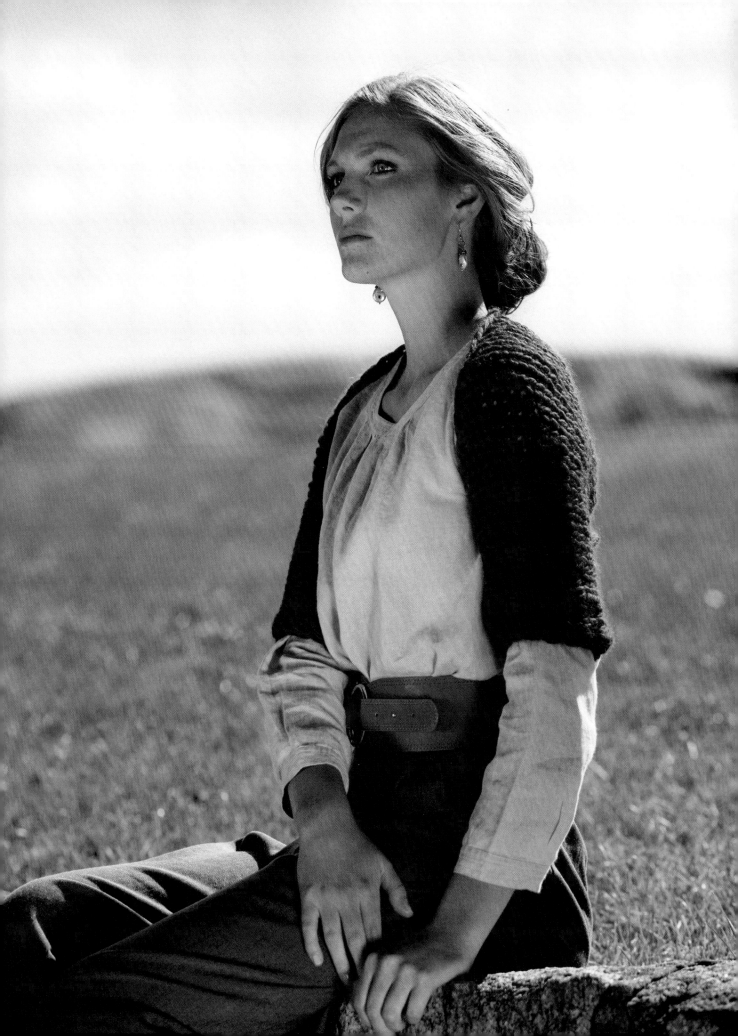

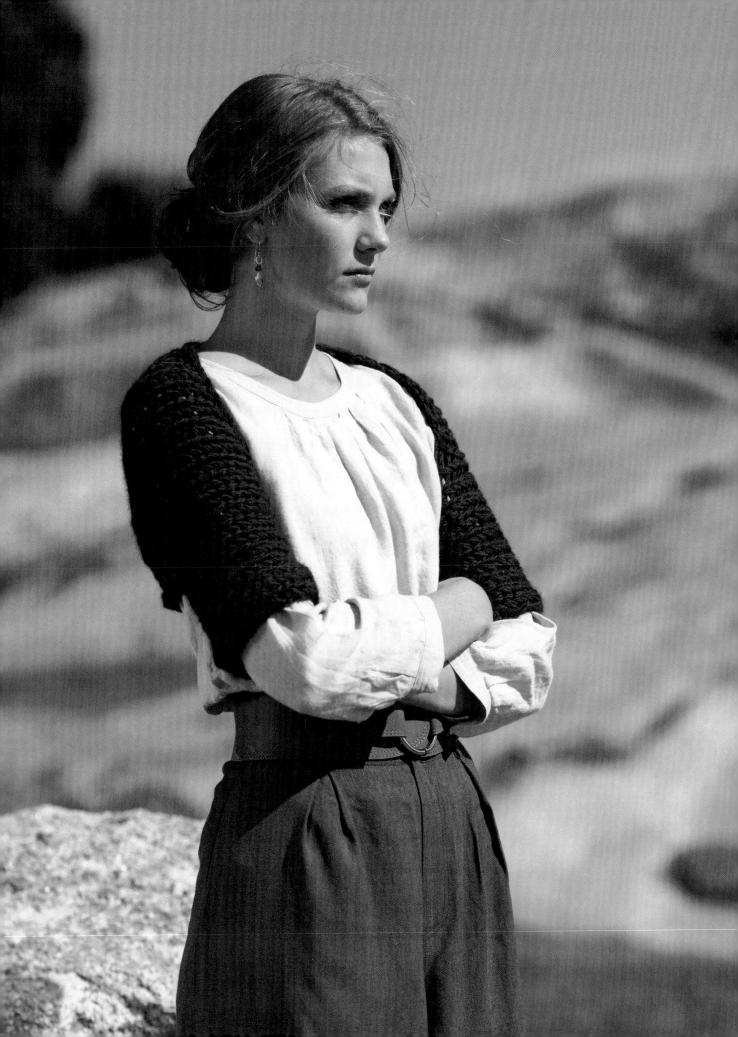

SHRUG

Use provisional method (see Glossary) to CO 48 sts. Do not join; work back and forth in rows.

Row 1 (RS): Sl 1 pwise wyb, knit to end.

Shape Body with Short-Rows (see Glossary)

Short-Row 1 (WS): Sl 1 pwise wyf, p26, wrap next st and turn so RS is facing; (RS) k4, wrap next st and turn so WS is facing.

Short-Row 2: P4, purl wrap together with the st it wraps, p2, wrap next st and turn so RS is facing; (RS) k7, knit wrap together with the st it wraps, k2, wrap next st and turn so WS is facing.

Short-Row 3: P10, purl wrap together with the st it wraps, p2, wrap next st and turn so RS is facing; (RS) k13, knit wrap together with the st it wraps, k2, wrap next st and turn so WS is facing.

Short-Row 4: P16, purl wrap together with the st it wraps, p3, wrap next st and turn so RS is facing; (RS) k20, knit wrap together with the st it wraps, k3, wrap next st and turn so WS is facing.

Next Row (WS): P24, purl wrap together with the st it wraps, purl to end.

Next Row (RS): Sl 1 pwise wyb, k35, knit wrap together with the st it wraps, knit to end.

Measure your upper arm. This measurement will be used when measuring the sleeve edge length of the shrug. Continue working in St st (knit on RS, purl on WS, and slipping the first st of every row) until piece measures the desired upper arm measurement, measuring along the side edges, excluding the short-rows.

Join the Sleeves

First Sleeve

Carefully remove waste yarn from provisional cast-on edge, and place 48 sts onto a second cir. Holding the 2 cir needles parallel, starting at one outer sleeve edge and working toward the center, use Kitchener st (see Glossary) to join as many sts as needed to have the sleeves reach your underarms. Keep yarn attached and set this sleeve aside.

Note: 11 sts were joined for the sample. About 8" (20.5 cm) to 8½" (21.5 cm) is a recommended average length.

Second Sleeve

Join a second ball of yarn and starting at the outer edge on the second sleeve and working toward the center, use Kitchener st to join the same number of sts as for the first sleeve. BO rem sts across the front needle. Fasten off the second ball of yarn.

Turn and BO the rem sts across the other cir needle using the first ball of yarn. Fasten off.

FINISHING

Weave in ends and close the holes that will be on either side by where the sleeves end at the underarms. If you mimic the sts around the holes as if grafting, you should get a clean closure instead of trying to sew them shut.

Block if desired.

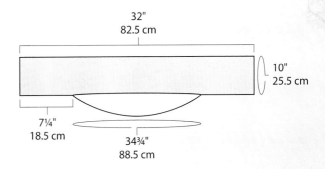

32"
82.5 cm

10"
25.5 cm

7¼"
18.5 cm

34¾"
88.5 cm

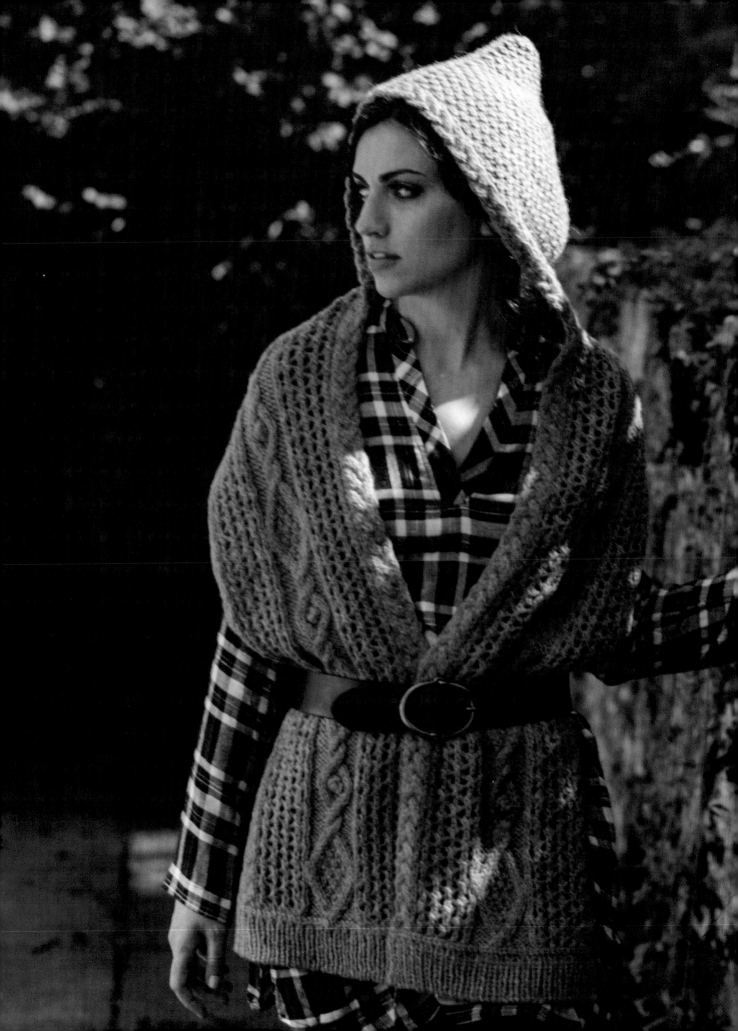

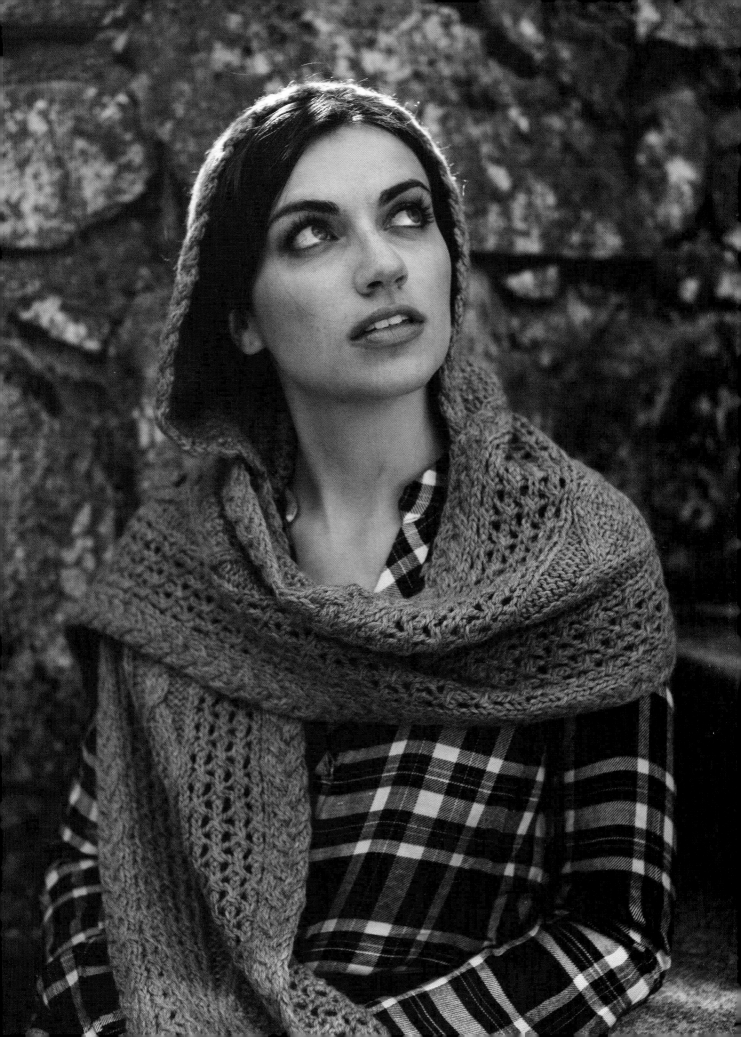

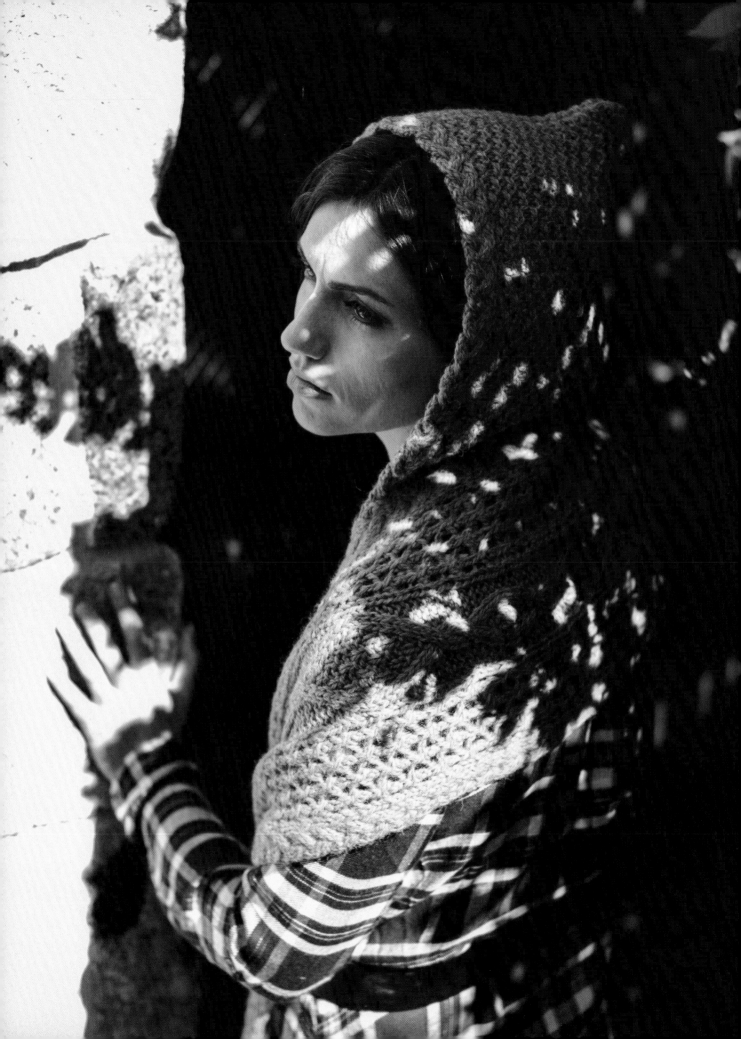

Row 22: Sl 1 pwise wyf, k2, 2/2LC, [k1, yo] twice, sk2p, yo, k1, yo, sk2p, k1, p4, k2, p1, k2, p4, [k1, yo] twice, sk2p, yo, k1, yo, sk2p, k1, 2/2RC, k3.

Row 23: Rep Row 1.

Row 24: Rep Row 20.

Row 25: Rep Row 1.

Row 26: Sl 1 pwise wyf, k2, 2/2LC, [k1, yo] twice, sk2p, yo, k1, yo, sk2p, k1, p3, 2/1RPC, p1, 2/1LPC, p3, [k1, yo] twice, sk2p, yo, k1, yo, sk2p, k1, 2/2RC, k3.

Row 27: Sl 1 pwise wyf, p16, [k3, p2] twice, k3, purl to last st, k1.

Row 28: Sl 1 pwise wyf, 2/2RC, k3, [sk2p, yo, k1, yo] twice, k1, p2, 2/1RPC, p3, 2/1LPC, p2, k1, [sk2p, yo, k1, yo] twice, k3, 2/2LC, k1.

Row 29: Sl 1 pwise wyf, p16, k2, p2, k2, MB (see above), k2, p2, k2, purl to last st, k1.

Row 30: Sl 1 pwise wyf, k2, 2/2LC, [k1, yo] twice, sk2p, yo, k1, yo, sk2p, k1, p2, 2/1LPC, p3, 2/1RPC, p2, [k1, yo] twice, sk2p, yo, k1, yo, sk2p, k1, 2/2RC, k3.

Row 31: Rep Row 27.

Row 32: Sl 1 pwise wyf, 2/2RC, k3, [sk2p, yo, k1, yo] twice, k1, p3, 2/1LPC, p1, 2/1RPC, p3, k1, [sk2p, yo, k1, yo] twice, k3, 2/2LC, k1.

Row 33: Rep Row 1.

Row 34: Rep Row 2.

Row 35: Rep Row 1.

Row 36: Sl 1 pwise wyf, 2/2RC, k3, [sk2p, yo, k1, yo] twice, k1, p4, k2, p1, k2, p4, k1, [sk2p, yo, k1, yo] twice, k3, 2/2LC, k1.

Rep Rows 1–36 two more times, then work Rows 1–10 once.

Next Row (WS): Work Row 11 of Scarf Cable Panel, placing a removable marker into the first slipped st.

Work Rows 12–36 of Scarf Cable Panel, rep Rows 1–36 of Scarf Cable Panel once, then work Rows 1–10 once more.

Next Row (WS): Work Row 11 of Scarf Cable Panel, placing a removable marker into the first slipped st.

Work Rows 12–36 of Scarf Cable panel, rep Rows 1–36 of Scarf Cable Panel two more times, then work Rows 1–20 once more.

Lateral Braid

Change to smaller needles.

Work Row 21 of Scarf Cable Panel.

Next Row (RS): Make a lateral braid.

Ribbing

Change to larger straight needles.

Beg with a WS row, work 11 rows of K1, P1 Rib, ending after a WS row.

BO all sts using the sewn bind-off method (see Glossary).

HOOD

With larger needles and RS of scarf facing, beg with the marked st, pick up and knit (see Glossary) 1 st in each of the next 72 slipped sts along the selvedge edge of the scarf, ending just before the next m—72 sts. Remove markers.

Work Rows 1–4 of Hood Pattern (see Stitch Guide or chart on page 64) until piece meas 12" (30.5 cm) from picked-up sts, ending after a WS row.

Seam Hood

Place 36 sts onto cir needle and fold hood so the RS's are facing each other, join using the three-needle BO (see Glossary).

FINISHING

Weave in ends. Block to measurements.

To block, soak in cool water, then roll in a dry towel and squeeze to remove excess moisture. Lay hood over a balloon, large bowl, or balled-up towel and allow it to air-dry completely.

HOOD CHART

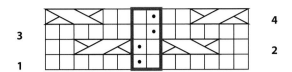

SCARF CABLE PANEL CHART

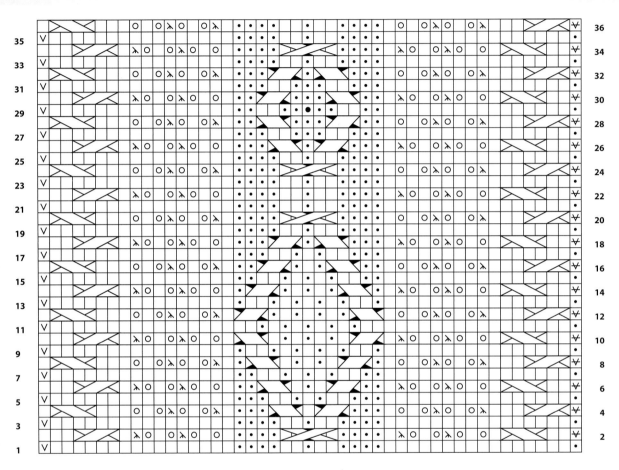

	knit on RS, purl on WS		2/2RC (see Stitch Guide)
•	purl on RS, knit on WS		2/2LC (see Stitch Guide)
⅄	sl 1 pwise wyf on RS		2/1/2RPC (see Stitch Guide)
V	sl 1 pwise wyf on WS		2/1RPC (see Stitch Guide)
o	yo		2/1LPC (see Stitch Guide)
⅄	sk2p		pattern repeat
●	MB (see Stitch Guide)		

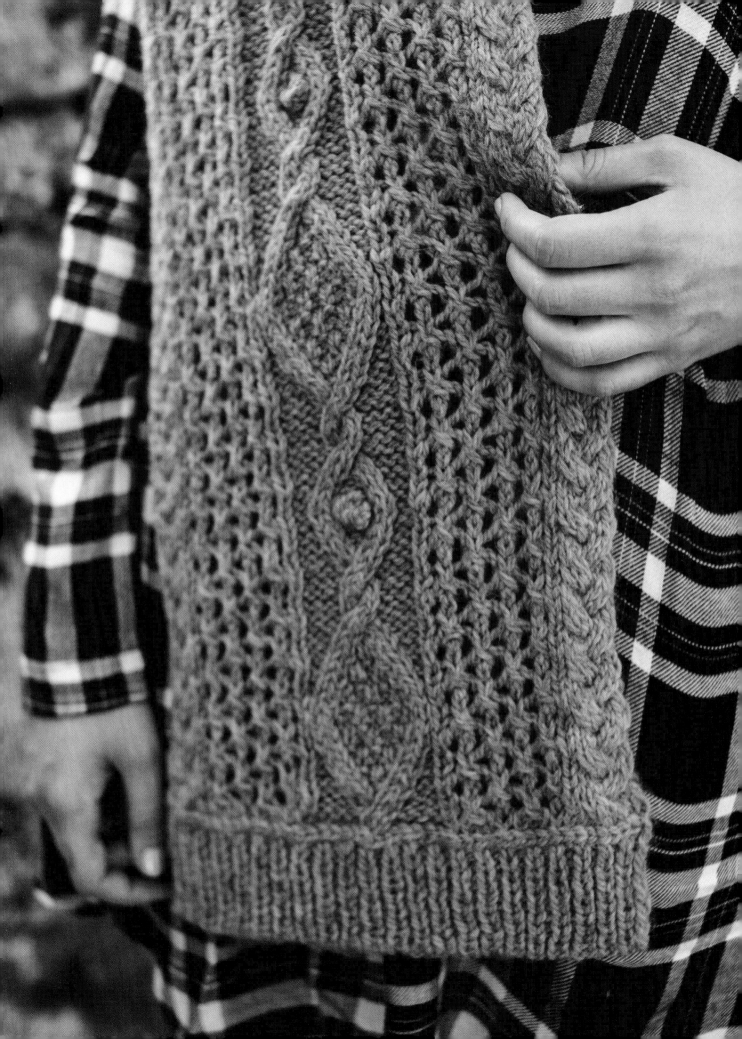

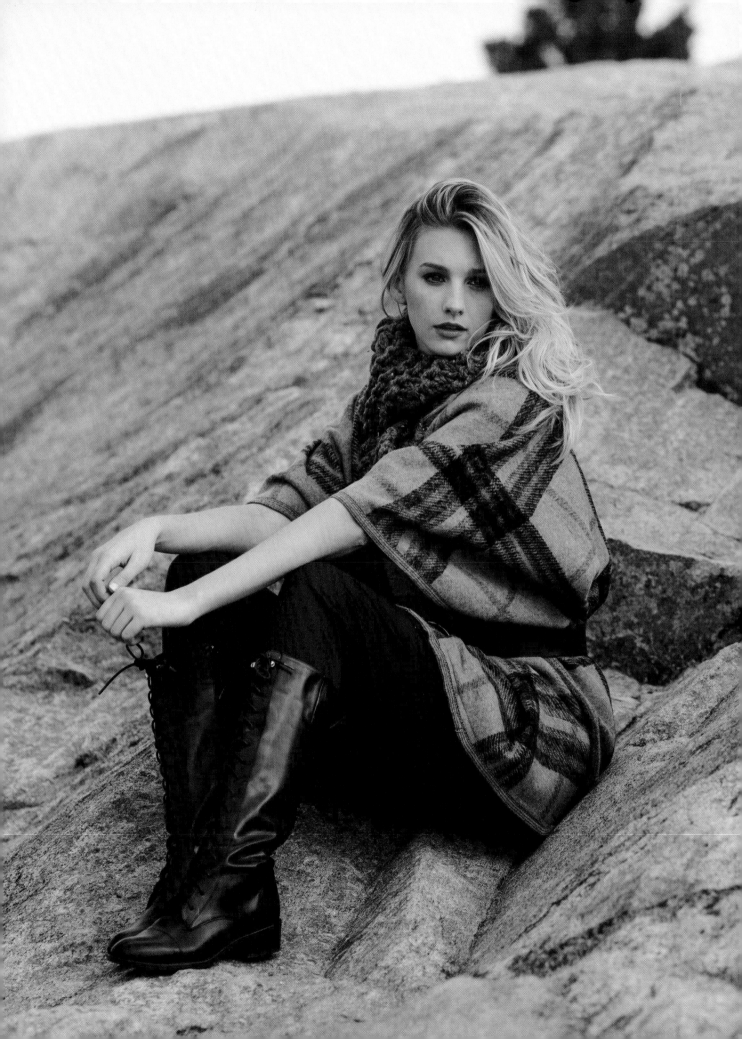

SASSENACH COWL

Slip on Claire's signature cowl to channel your inner outlander. This garter-stitch cowl couldn't be simpler to knit, but worked with huge needles in bulky yarn held doubled, it becomes a dramatic statement piece.

Designed by Kristen Brooks

Finished Size

About 48" (122 cm) in circumference and 6" (15 cm) wide.

Yarn

Bulky weight (#6 Super Bulky).

Shown here: Lion Brand Wool-Ease Thick & Quick Tweeds (80% acrylic, 20% wool; 106 yd [97 m]/6 oz [170 g]): barley, 2 skeins.

Needles

Size U.S. 50 (25 mm) straight needles.

Adjust needle size if necessary to obtain the correct gauge.

Notions

Tapestry needle.

Gauge

5¼ sts and 6½ rows = 4" (10 cm) in garter st with 2 strands of yarn held together.

Notes

The sample cowl was seamed, but you can use a provisional cast-on (see Glossary) and Kitchener st (see Glossary) or three-needle bind-off (see Glossary) instead.

Hold 2 strands of yarn together throughout the knitting. Use only 1 strand for seaming.

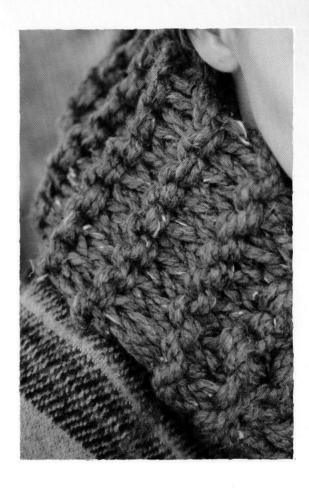

COWL

With 2 strands of yarn held together, use the long-tail method (see Glossary) to CO 8 sts.

Work in garter st (knit all sts, every row) for 78 rows.

BO all sts, leaving a long tail for seaming.

FINISHING

Sew CO and BO ends together, being careful not to twist. Weave in ends. Block to measurements.

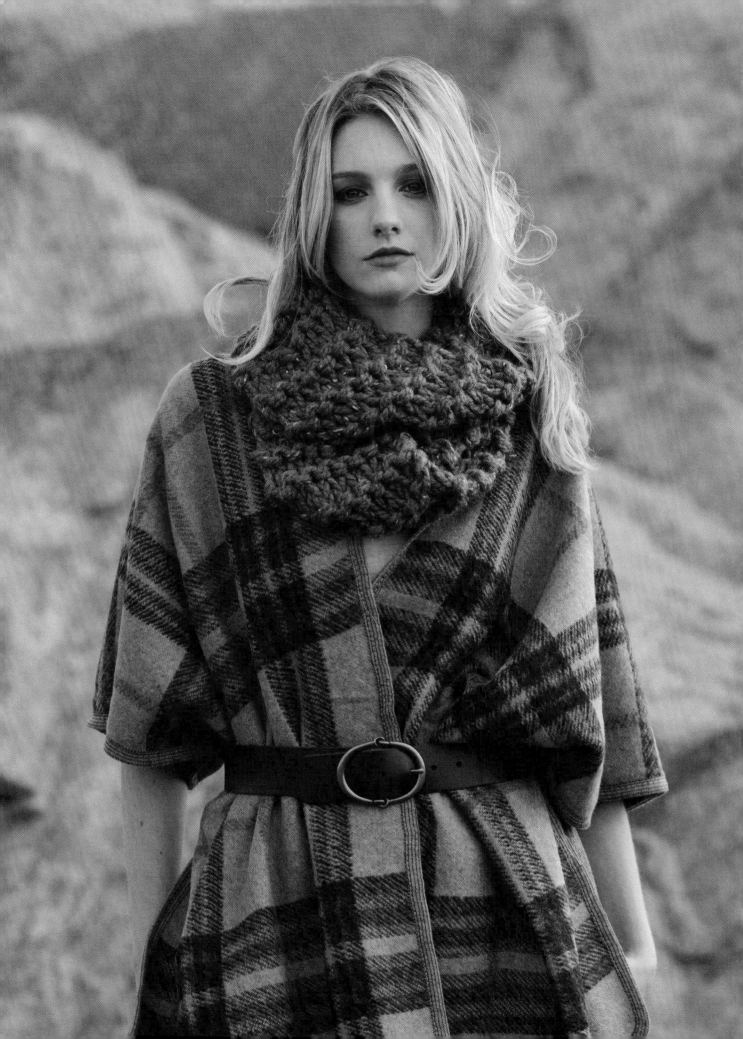

STANDING STONES STOCKINGS

Worked in a nubby tweed yarn, these knee-high cabled socks evoke the rugged stones of Craigh na Dun. A timeless design for any century.

Designed by Kalurah Hudson

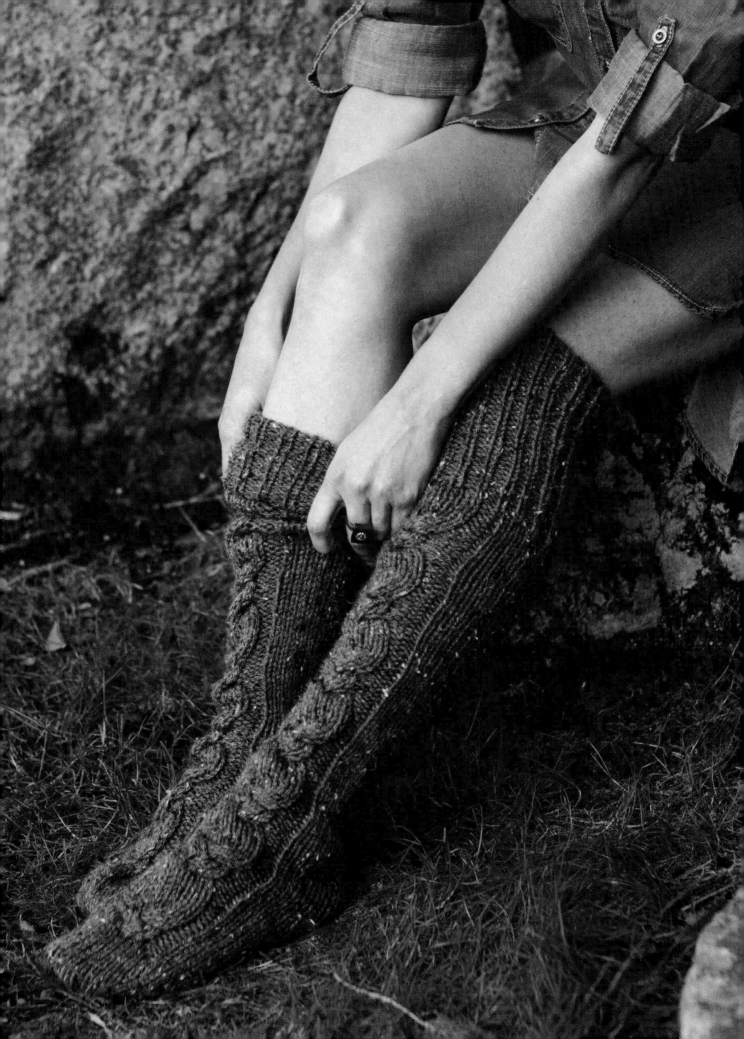

Finished Size

About 8½" (21.5 cm) in circumference and 30" (736 cm) long.

Pattern is written to fit an average adult; see Notes for how to customize.

Yarn

Aran weight (#4 Medium).

Shown here: Lion Brand Vanna's Choice Tweeds (100% acrylic; 145 yd [133 m]/3 oz [85 g]): #403 barley, 2 skeins.

Needles

Size U.S. 10 (6 mm): set of 4 double-pointed (dpn).

Adjust needle size if necessary to obtain the correct gauge.

Notions

Cable needle (cn); stitch markers (m); tapestry needle.

Gauge

14 sts and 22 rnds = 4" (10 cm) in Stockinette st worked in the rnd; 13 sts = 2½" (6.5 cm) in Left Sock and Right Sock Cable Panels, stretched.

Notes

Socks will stretch to fit a calf circumference of about 14" (35.5 cm) to 16" (45.5 cm). For wider or narrower socks, use gauge measurements and simply add or subtract an even number of sts when casting on. Center the cable panel on the first needle when establishing the pattern.

STITCH GUIDE

3/3LC: Sl 3 sts to cn and hold to front, k3, k3 from cn.

3/3RC: Sl 3 sts to cn and hold to back, k3, k3 from cn.

Left Sock Cable Panel: (panel of 13 sts)

See also chart on page 75.

Rnds 1 and 5: P2, k3, 3/3LC (see above), p2.

Rnds 2, 4, 6, and 8–18: P2, k9, p2.

Rnds 3 and 7: P2, 3/3RC (see above), k3, p2.

Rep Rnds 1–18 for patt.

Right Sock Cable Panel: (panel of 13 sts)

See also chart on page 75.

Rnds 1 and 5: P2, 3/3RC, k3, p2.

Rnds 2, 4, 6, and 8–18: P2, k9, p2.

Rnds 3 and 7: P2, k3, 3/3LC, p2.

Rep Rnds 1–18 for patt.

K1, P1 Rib: (multiple of 2 sts)

Rnd 1: ★K1, p1; rep from ★.

Rep Rnd 1 for patt.

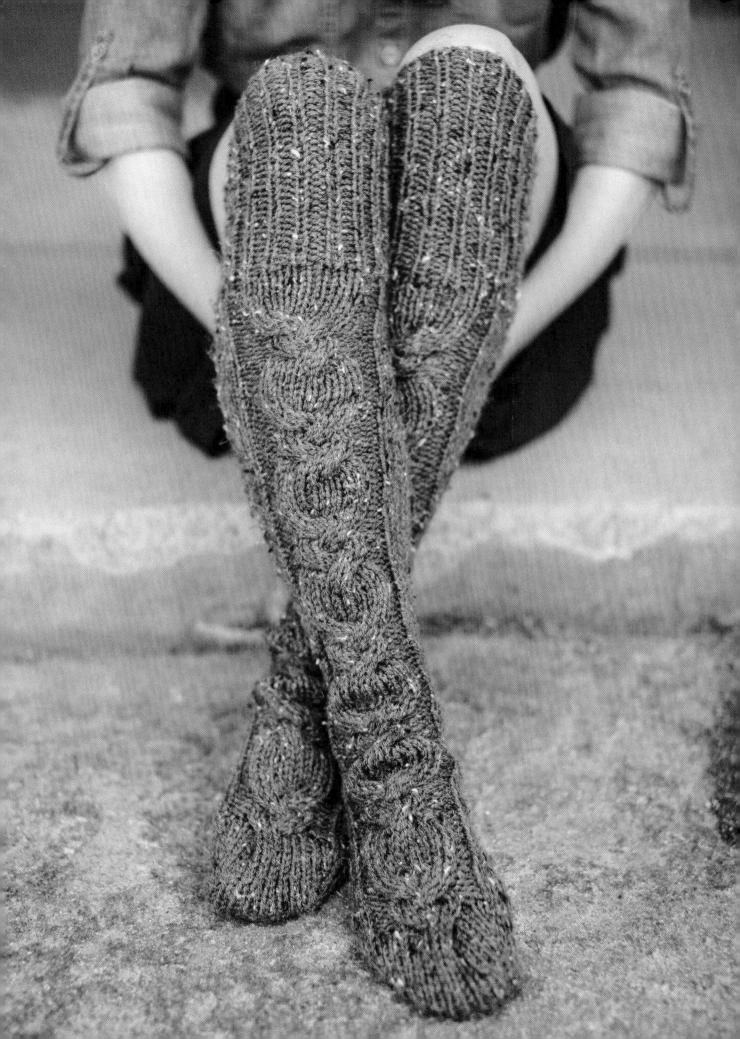

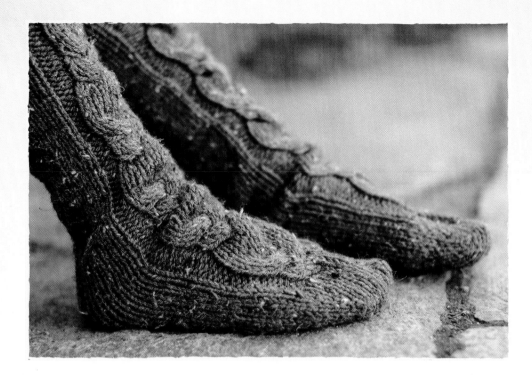

LEFT SOCK

Toe

With dpn and using Judy's Magic Cast-On method (see Glossary), CO 18 sts.

Divide sts over 3 dpn as follows: 9 sts on needle 1, 4 sts on needle 2, and 5 sts on needle 3.

Pm for beg of rnd and join to work in the rnd, being careful not to twist sts.

Knit 1 rnd.

Inc Rnd: On needle 1: K1, M1R (see Glossary), knit to last st on needle 1, M1L (see Glossary), k1; on needle 2, k1, M1R, knit to end of needle 2; on needle 3, knit to last st, M1L, k1—4 sts inc'd.

Knit 2 rnds.

Rep the last 3 rnds 3 more times—34 sts.

Body

Est Patt: Work 2 sts in St st (knit all sts, every rnd), work 13 sts in Left Sock Cable Panel (see Stitch Guide or chart), work in St st to end.

Cont working as est until Rnds 1–18 of Left Sock Cable Panel have been completed 7 times.

Ribbing

Work K1, P1 Rib (see Stitch Guide) for 7" (18 cm).

BO all sts using the sewn bind-off method (see Glossary).

RIGHT SOCK

Work the same as for the left sock, working the
Right Sock Cable Panel (see Stitch Guide or chart)
in place of the Left Sock Cable Panel.

FINISHING

Weave in ends. Block lightly if desired.

LEFT SOCK CABLE PANEL CHART **RIGHT SOCK CABLE PANEL CHART**

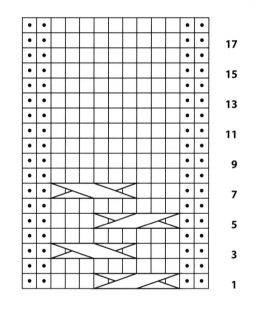

☐ knit

• purl

3/3RC (see Stitch Guide)

3/3LC (see Stitch Guide)

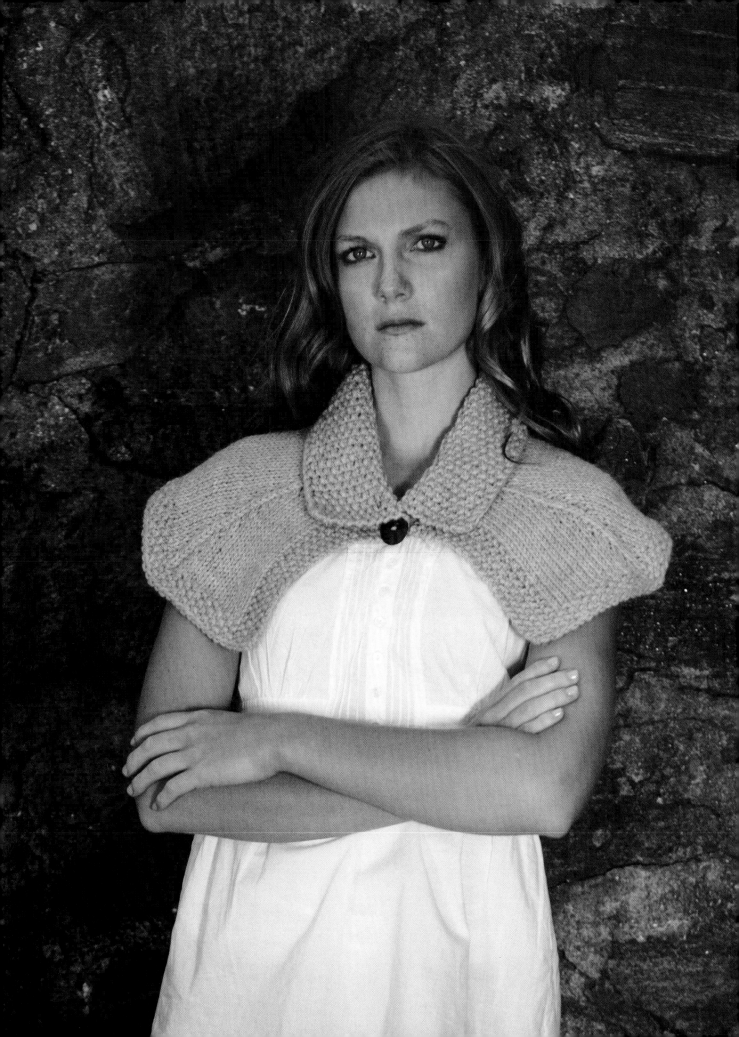

BOAR HUNT CAPELET

Both warm and elegant, this bonnie capelet works up quickly in a soft, bulky-weight yarn. Wear it over a blouse or tuck it under a coat with just the collar peeking out.

Designed by Tina Baker

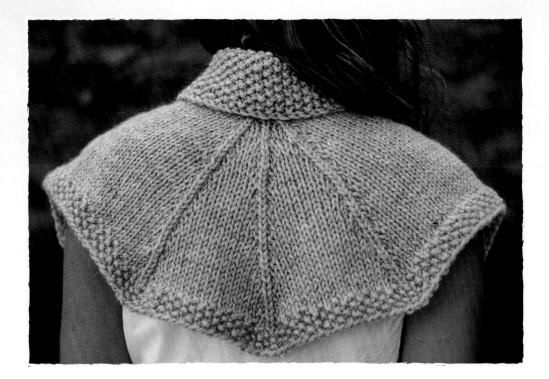

Finished Size

About 15¼" (38.5 cm) in neck circumference.

Yarn

Chunky weight (#5 Bulky).

Shown here: Universal Yarn Deluxe Chunky (100% wool; 120 yd [110 m]/3½ oz [100 g]): #91901 oatmeal heather, 2 skeins.

Needles

Size U.S. 9 (5.5 mm): 32" (81.5 cm) circular (cir) needles.

Adjust needle size if necessary to obtain the correct gauge.

Notions

Stitch markers (m); 1" (2.5 cm) button; tapestry needle.

Gauge

14 sts and 20 rows = 4" (10 cm) in Stockinette st.

Note

Circular needle is used to accommodate large number of sts. Do not join; work back and forth in rows.

CAPELET

CO 159 sts. Do not join; work back and forth in rows.

Work 5 rows even in Seed St (see Stitch Guide).

Set-up Row (RS): Work 5 sts in Seed St as est, pm, k13, s2kp, pm, k37, [s2kp, pm, k17] twice, s2kp, pm, k37, s2kp, pm, k13, pm, work last 5 sts in Seed St as est—149 sts.

Shape Capelet

Row 1 (WS): Work in Seed St to first m, sl m, purl to last m, sl m, work in Seed St to end.

Row 2 (RS): Work in Seed St to first m, sl m, [knit to 1 st before next m, M1L (see Glossary), s2kp removing m, pm, M1R (see Glossary)] 5 times, knit to last m, sl m, work in Seed St to end.

Row 3: Rep Row 1.

Dec Row 4: Work in Seed St to first m, sl m, [knit to 1 st before next m, s2kp removing m, pm] 5 times, knit to last m, sl m, work in Seed St to end—10 sts dec'd.

Rep the last 4 rows 7 more times—69 sts rem.

Next Row (WS): Work in Seed St to first m, sl m, purl to last m, sl m, work in Seed St to end.

Dec Row (RS): Work in Seed St to first m, sl m, [knit to 1 st before next m, s2kp removing m] twice, k1, remove m, s2kp removing m, knit to 1 st before next m, s2kp removing m, knit to last m, sl m, work in Seed St to end—53 sts rem.

Next Row (WS): Work in Seed St to first m, sl m, purl to last m, sl m, work in Seed St to end.

Next Row (RS): Work in Seed St to first m, sl m, knit to last m, sl m, work in Seed St to end.

Next Row (WS): Work in Seed St to first m, remove m, purl to last m, remove m, work in Seed St to end.

Buttonhole Row (RS): P1, k1, BO 2 sts, work in Seed St to end.

Next Row (WS): Work in Seed St to BO sts, use the backward-loop method (see Glossary) to CO 2 sts, k1, p1.

Work 3 more rows even in Seed St, ending after a RS row.

COLLAR

Inc Row (WS): P1, k1, p1, ★M1L, [p1, k1] twice, p1; rep from ★ to end—63 sts.

Work 15 rows even in Seed St, ending after a RS row.

BO all sts in patt.

FINISHING

Sew button on right front at neckline, so it lines up with buttonhole.

Weave in ends. Block to measurements.

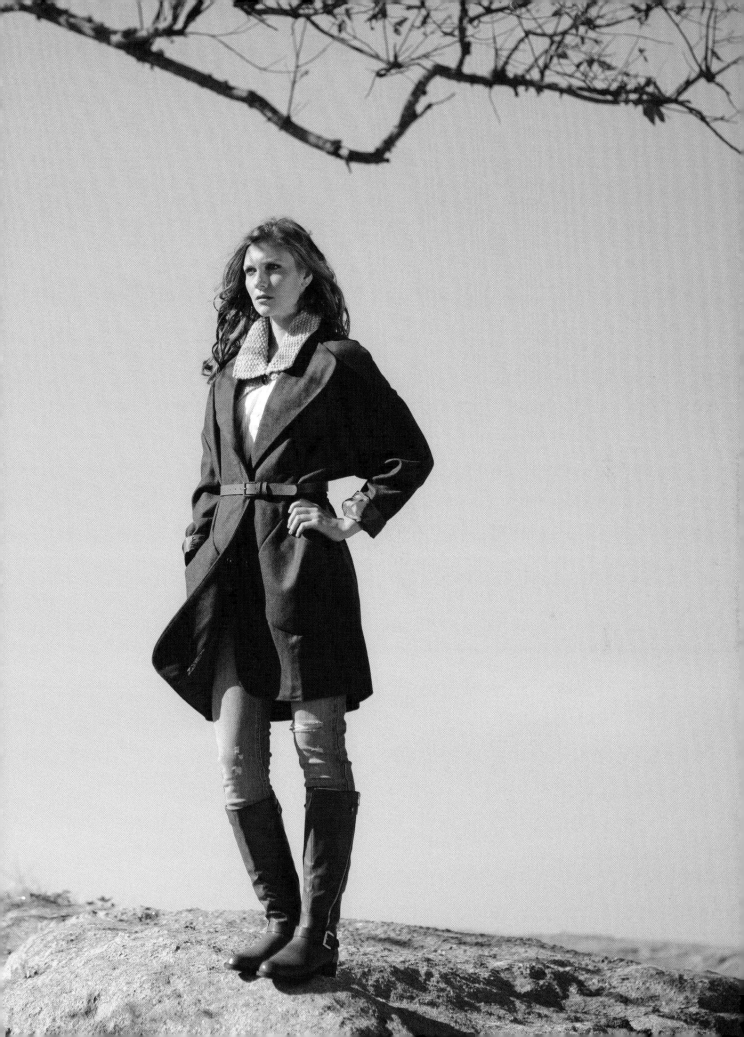

BRIMSTONE FAUX FUR COWL

This reversible cowl is extremely warm—perfect for galloping across the hills or strolling around town. The garter–stitch pattern couldn't be simpler, but knit in faux fur yarn, it's the epitome of luxury.

Designed by Claudia Maheux

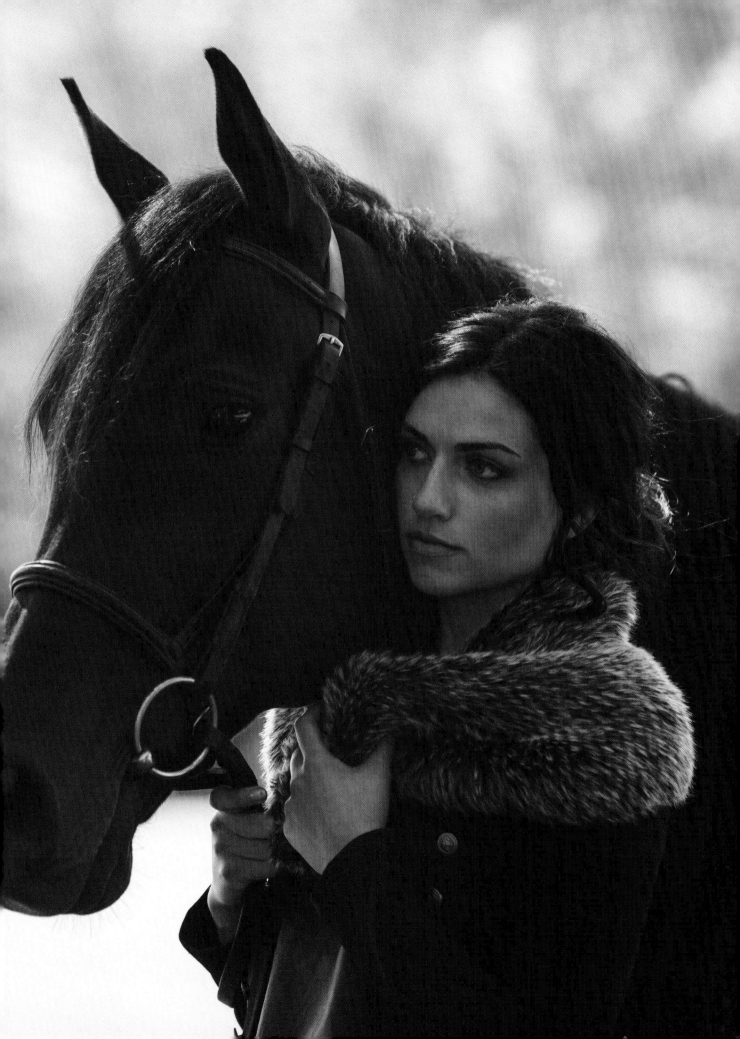

Finished Size

About 11½" (29 cm) wide and 34" (86.5 cm) circumference.

Yarn

Chunky weight (#5 Bulky).

Shown here: Louisa Harding Luzia (80% viscose, 20% nylon; 43 yd [39.5 m]/1¾ oz [50 g]): #07 otter, 7 skeins.

Needles

Size U.S. 10 (6 mm): straight needles.

Adjust needle size if necessary to obtain the correct gauge.

Notions

Size J/10 (6 mm) crochet hook and smooth waste yarn for provisional cast-on; tapestry needle.

Gauge

About 19 sts and 29 rows = 4" (10 cm) in Stockinette st, holding 2 strands of yarn together. Row gauge is not critical for this pattern.

Note

Due to the nature of the Luzia yarn, counting the stitches and rows over 4" (10 cm) may be challenging. To measure your gauge, knit a swatch of 19 sts and 29 rows in garter st. It should measure about 4" square.

COWL

Use provisional method (see Glossary) to CO 55 sts.

Holding 2 strands of working yarn together, knit in garter st (knit all sts, every row) until piece meas 34" (86.5 cm) from beg. Break yarn, leaving a tail about 3 yd (2¾ m) long.

FINISHING

Carefully remove waste yarn from provisional cast-on and place 55 sts onto empty needle. Use the tail and tapestry needle to graft the live sts together using Kitchener st (see Glossary).

Weave in ends. Block to measurements.

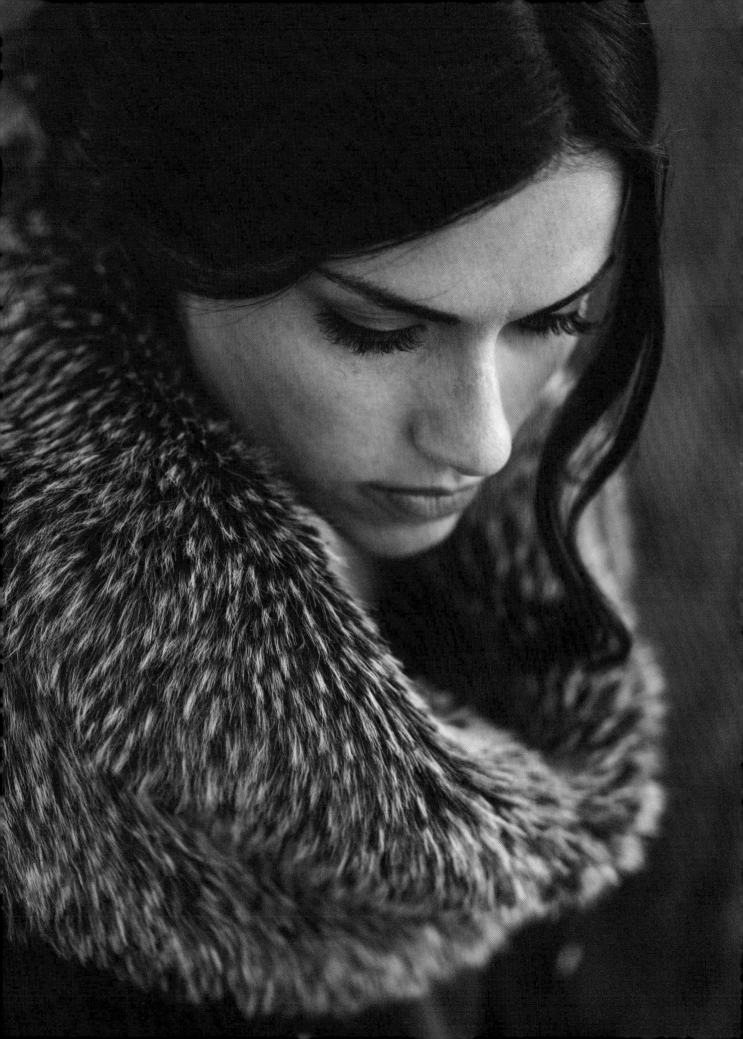

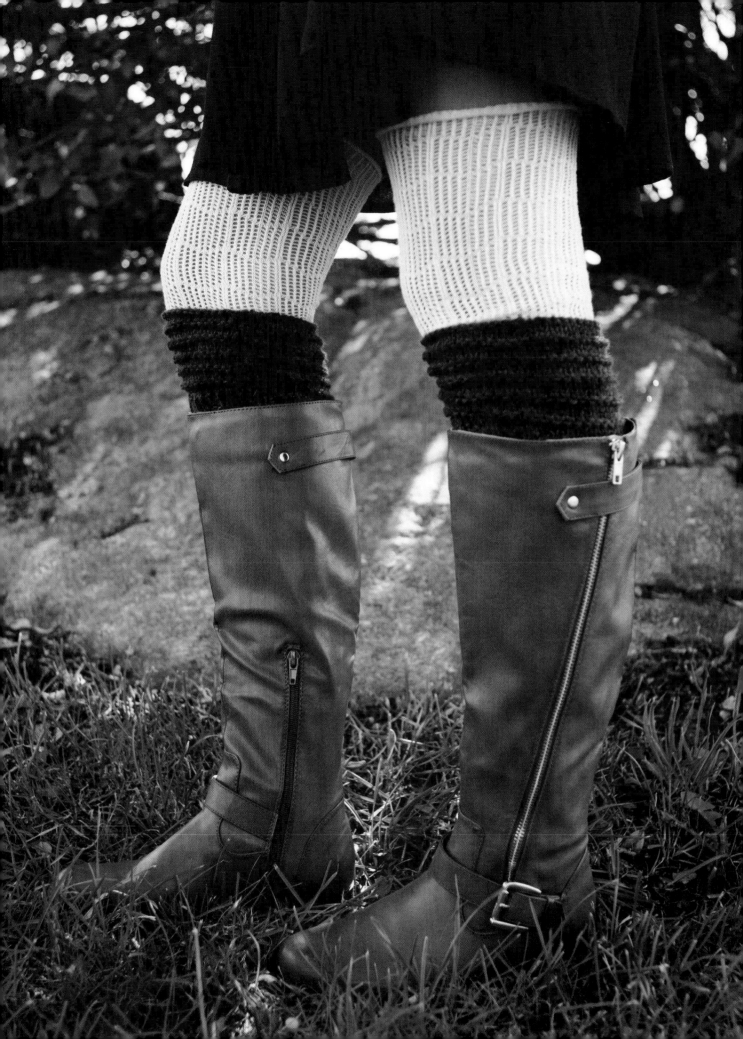

CLAN FRASER BOOT CUFFS

These unisex cuffs easily add a bit of warmth and texture to your outfit. They knit up quickly in a simple garter-ridge pattern and are perfect for a lass or a lad. Make a pair for everyone in your clan!

Designed by Emma Sadler

Finished Size

About 11¾" (30 cm) in circumference at the widest point and 8" (20.5 cm) tall.

Yarn

Worsted weight (#4 Medium).

Shown here: Caron Simply Soft Ombre (100% acrylic; 208 yd [190 m]/4 oz [113 g]): sticks and stones, 1 skein.

Needles

Sizes U.S. 7 (4.5 mm) and 9 (5.5 mm): straight needles.

Adjust needle sizes if necessary to obtain the correct gauge.

Notions

Tapestry needle.

Gauge

17 sts and 28 rows = 4" (10 cm) in Garter Ridge Pattern with larger needles.

STITCH GUIDE

K2, P2 Rib: (multiple of 4 sts + 2)

Row 1 (RS): K2, ★p2, k2; rep from ★.

Row 2 (WS): P2, ★k2, p2; rep from ★.

Rep Rows 1 and 2 for patt.

Garter Ridge Pattern: (any number of sts)

Row 1 (RS): Knit.

Row 2 (WS): K1, purl to last st, k1.

Row 3: Knit.

Row 4: Knit.

Rep Rows 1–4 for patt.

BOOT CUFF (Make 2)

With smaller needles, CO 50 sts.

Work in K2, P2 Rib (see Stitch Guide) until piece meas 4" (10 cm) from beg, ending after a WS row.

Change to larger needles.

Work Rows 1–4 of Garter Ridge Patt (see Stitch Guide) 5 times, then work Rows 1–3 once more.

BO all sts kwise.

FINISHING

Block pieces to measurements.

Sew side seams. Weave in ends.

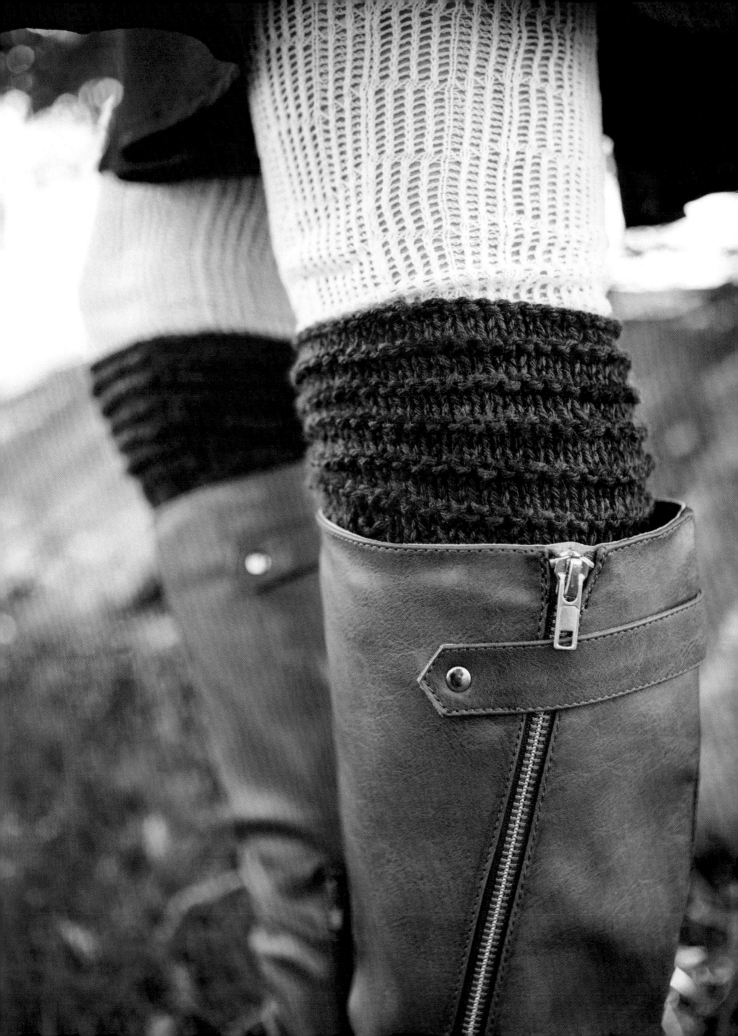

LOVE TRIANGLE ARM WARMERS

These pretty fingerless gloves feature an eye-catching center cable set off by reverse stockinette stitch. The cabled design is inspired by the intertwining of Claire's relationships with Frank and Jamie.

Designed by Kalurah Hudson

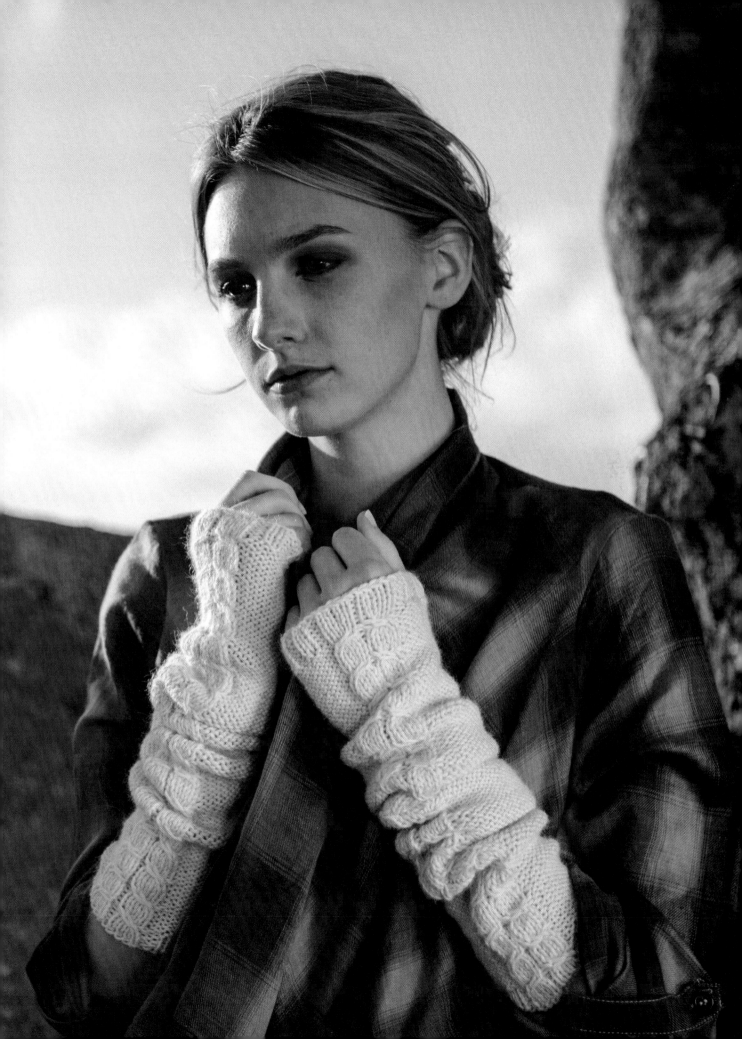

Finished Size

About 7" (18 cm) in circumference and 17¾" (45 cm) long.

Yarn

Worsted weight (#4 medium).

Shown here: Cascade Eco Alpaca (100% baby alpaca; 220 yd [200 m]/3½ oz [100 g]): #1510 natural, 2 skeins.

Needles

Size U.S. 5 (3.75 mm): set of 4 or 5 double-pointed (dpn).

Size U.S. 7 (4.5 mm): set of 4 or 5 dpn.

Size U.S. 10 (6 mm): 1 needle for BO.

Adjust needle sizes if necessary to obtain the correct gauge.

Notions

Cable needle (cn); stitch marker (m); tapestry needle.

Gauge

24 sts and 28 rnds = 4" (10 cm) in Rev St st worked in the rnd (purl all sts, every rnd) on medium-size needles.

9 sts = 1¼" (3 cm) in Cable Panel worked in the rnd on medium-size needles.

STITCH GUIDE

1/3LC: Sl 1 st to cn and hold to front, k3, k1 from cn.

1/3RC: Sl 3 sts to cn and hold to back, k1, k3 from cn.

Cable Panel: (panel of 9 sts)

See also chart.

Rnd 1: 1/3LC (see above), p1, 1/3RC (see above).

Rnds 2–6: K4, p1, k4.

Rep Rnds 1–6 for patt.

CABLE PANEL CHART

5

3

1

☐ knit

• purl

✖ 1/3LC (see Stitch Guide)

✖ 1/3RC (see Stitch Guide)

ARM WARMER (Make 2)

Using medium-size needles, CO 43 sts. Divide sts evenly over 3 or 4 dpn, pm for beg of rnd and join to work in the rnd, being careful not to twist sts.

Est Ribbing: [P2, k2] 6 times, p2, k4, p1, k4, [p2, k2] twice.

Change to smallest dpn.

Cont working in ribbing as est for 4 more rnds.

Est Cable Panel: Work 26 sts in Rev St st (purl all sts, every rnd), work 9 sts in Cable Panel (see Stitch Guide or chart), work 8 sts in Rev St st to end.

Cont working in Rev St st and Cable Panel as est until Rnds 1–6 of Cable Panel have been completed 19 times, then work Rnd 1 once more.

Est Ribbing: [P2, k2] 6 times, p2, k4, p1, k4, [p2, k2] twice.

Cont working in ribbing as est for 4 more rnds.

BO in ribbing, using largest-size needle.

FINISHING

Weave in ends. Block lightly if desired.

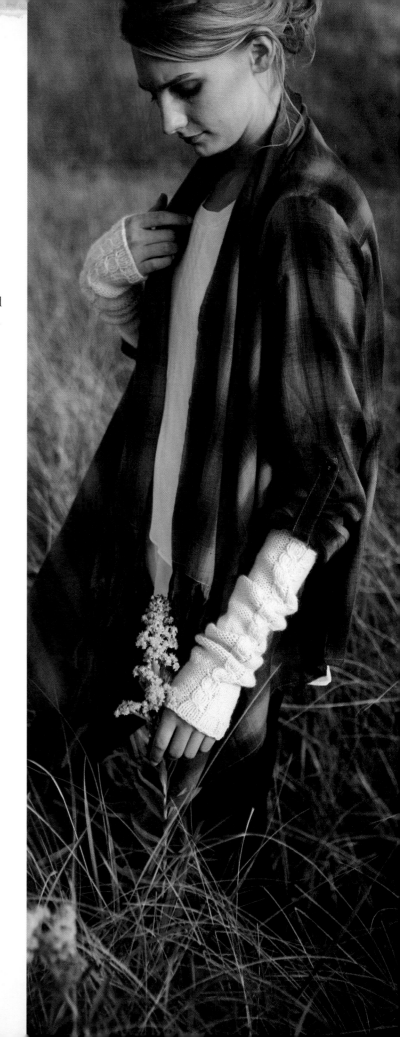

CASTLE LEOCH RIBBED COWL

Castles can get pretty chilly, and a sumptuous cowl will keep out the drafts. A deep forest-green yarn and a simple rib stitch combine to create a stunning accessory for modern-day lasses as well.

Designed by Karen Clements

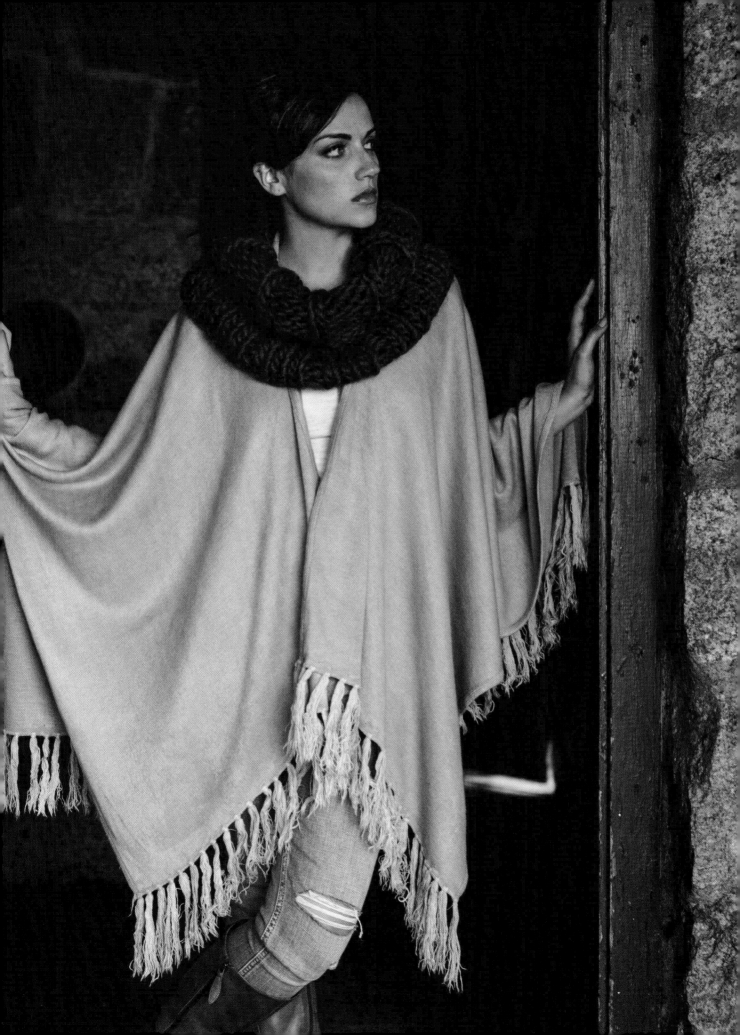

Finished Size

About 14" (35.5 cm) tall and 29" (74 cm) in circumference.

Yarn

Bulky weight (#6 Super Bulky).

Shown here: Cascade Magnum (100% wool; 123 yd [112.5 m]/8.82 oz [250 g]): #2445 shire, 1 skein.

Needles

Size U.S. 19 (15 mm): 24" (60 cm) circular (cir) needle.

Adjust needle size if necessary to obtain the correct gauge.

Notions

Stitch marker (m); tapestry needle.

Gauge

5½ sts and 7 rnds = 4" (10 cm) in K3, P1 Rib, worked in the rnd.

COWL

CO 40 sts. Pm for beg of rnd and join to work in the rnd, being careful not to twist sts.

Work in K3, P1 Rib until piece meas 14" (38 cm).

BO all sts in rib.

FINISHING

Weave in ends. Block lightly to measurements.

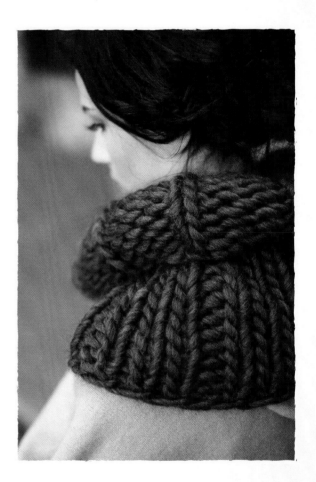

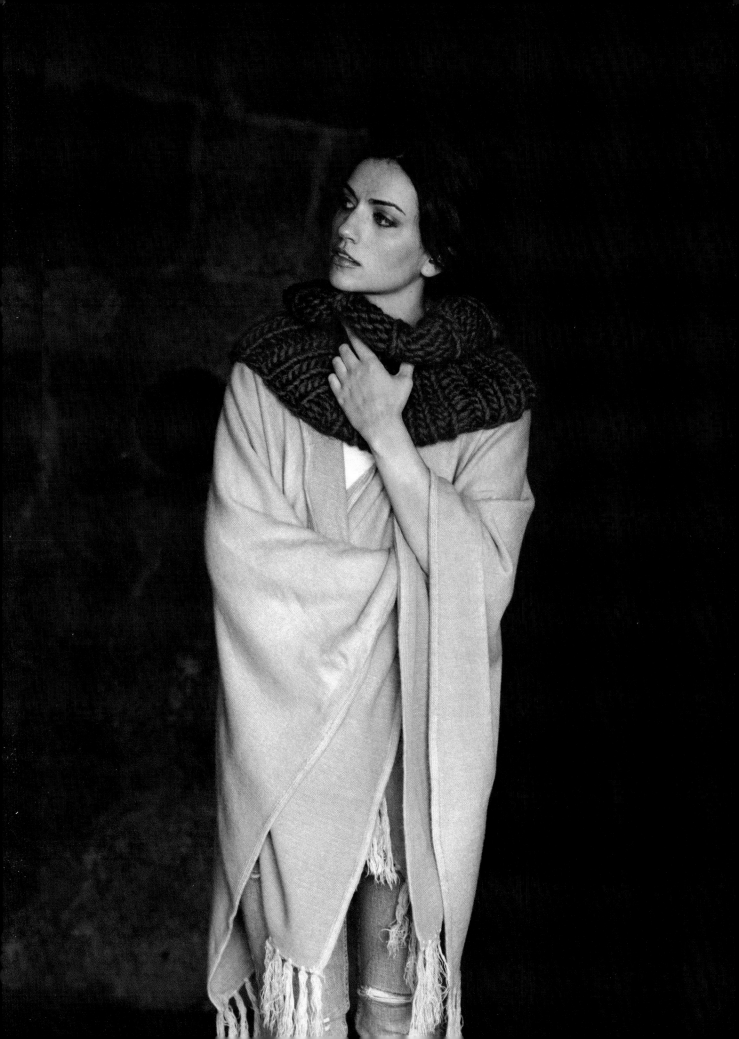

ABBREVIATIONS

beg	begin/beginning
cir	circular
cm	centimeter(s)
cn	cable needle
CO	cast on
cont	continue
dec(s)('d)	decrease(s)(d)
dpn	double-pointed needle(s)
est	establish(ed)
foll	follow(ing)
inc(s)('d)	increase(s)(d)
k	knit
k2tog	knit 2 stitches together; 1 stitch decreased (see Glossary)
k1f&b	knit into the front and back of stitch; 1 stitch increased (see Glossary)
kwise	knitwise
m	marker
M1	make 1 stitch; right or left slanting increase as indicated by R/L (see Glossary)
meas	measure(s)
p	purl
patt	pattern
pm	place marker
p2tog	purl 2 stitches together; 1 stitch decreased (see Glossary)
pwise	purlwise
rem	remain(ing)
rep	repeat(s)
rnd(s)	round(s)

RS	right side
s2kp	slip 2 stitches at the same time as if to knit, knit 1 stitch, pass slipped stitches over
sk2p	slip 1 stitch, knit 2 stitches together, pass slipped stitch over; 2 stitches decreased
sl	slip
ssk	slip, slip, knit slipped stitches together; 1 stitch decreased (see Glossary)
st(s)	stitch(es)
tbl	through back loop
WS	wrong side
wyb	with yarn in back
wyf	with yarn in front
yo	yarn over
[]	repeat instructions within brackets as written.
()	alternate instructions within parenthesis.

GLOSSARY

Bind-Offs

Jeny's Surprisingly Stretchy Bind-Off

Step 1. If the stitch to be bound off is a knit stitch, work a backward yo (bring yarn to the front over the needle; **Figure 1**). Knit the next stitch, then insert left needle into yo and lift it over the knit stitch **(Figure 2)**. If the stitch to be bound off is a purl stitch, work a standard yo **(Figure 3)**. Purl the next stitch, then insert left needle into yo and lift it over the purl stitch **(Figure 4)**.

Step 2. Rep Step 1 for the second stitch to be bound off. Insert left needle in second stitch from tip of right needle and lift it over the next stitch.

Rep Step 2 until all stitches have been bound off. As you get into the rhythm of this method, you may prefer to lift the yo and the previous stitch over the next stitch together in a single motion **(Figure 5)**.

Sewn Bind-Off

Cut the yarn three times the width of the knitting to be bound off and thread onto a tapestry needle. Working from right to left, ★insert tapestry needle purlwise (from right to left) through first two stitches **(Figure 1)** and pull the yarn through, then bring needle knitwise (from left to right) through the first stitch **(Figure 2)**, pull the yarn through, and slip this stitch off the knitting needle. Repeat from ★.

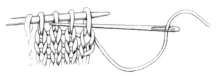

Figure 1

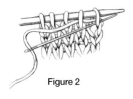

Figure 2

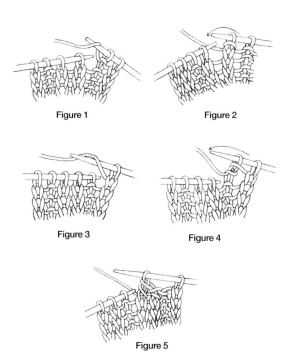

Figure 1

Figure 2

Figure 3

Figure 4

Figure 5

Standard Bind-Off

Knit the first stitch, ★knit the next stitch (two stitches on right needle), insert left needle tip into first stitch on right needle **(Figure 1)** and lift this stitch up and over the second stitch **(Figure 2)** and off the needle **(Figure 3)**. Repeat from ★ for the desired number of stitches.

Three-Needle Bind-Off

Place the stitches to be joined onto two separate needles and hold the needles parallel so that the right sides (or wrong sides, if specified in pattern) of knitting face each other. Insert a third needle into the first stitch on each of two needles **(Figure 1)** and knit them together as one stitch **(Figure 2)**, ★knit the next stitch on each needle the same way, then use the left needle tip to lift the first stitch over the second and off the needle **(Figure 3)**. Repeat from ★ until no stitches remain on first two needles. Cut yarn and pull tail through last stitch to secure.

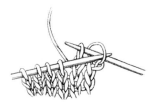

Figure 1

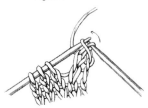

Figure 2

Figure 3

Figure 1

Figure 2

Figure 3

Blocking

Steam Blocking

Pin the pieces to be blocked to a blocking surface. Hold an iron set on the steam setting ½" (1.3 cm) above the knitted surface and direct the steam over the entire surface (except ribbing). You can get similar results by lapping wet cheesecloth on top of the knitted surface and touching it lightly with a dry iron. Lift and set down the iron gently; do not use a pushing motion.

Wet-Towel Blocking

Run a large bath or beach towel (or two towels for larger projects) through the rinse/spin cycle of a washing machine. Roll the knitted pieces in the wet towel(s), place the roll in a plastic bag, and leave overnight so that the knitted pieces become uniformly damp. Pin the damp pieces to a blocking surface and let air-dry thoroughly.

Cast-Ons

Backward-Loop Cast-On

*Loop working yarn and place it on needle backward so that it doesn't unwind. Repeat from *.

Cable Cast-On

If there are no stitches on the needles, make a slipknot of working yarn and place it on the left needle, then use the knitted method to cast on one more stitch—two stitches on needle. When there are at least two stitches on the left needle, hold needle with working yarn in your left hand. *Insert right needle between the first two stitches on left needle **(Figure 1)**, wrap yarn around needle as if to knit, draw yarn through **(Figure 2)**, and place new loop on left needle **(Figure 3)** to form a new stitch. Repeat from * for the desired number of stitches, always working between the first two stitches on the left needle.

Figure 1

Figure 2

Figure 3

Judy's Magic Cast-On

Hold two needles parallel in your right hand, one on top of the other and needle points facing to the left. Leaving a tail long enough to cast on the required number of stitches, drape the yarn over the top needle so the tail is in front and the ball yarn in back **(Figure 1)**. Cross the yarns so the tail is in the back and the ball yarn in the front, then place the thumb and index finger of your left hand between the two strands so that the tail is over your index finger and the ball yarn is over your thumb **(Figure 2)**. This forms the first stitch on the top needle.

*Pivoting both needles together, bring the bottom needle over the top of the finger yarn, then bring the finger yarn up from below the bottom needle, over the top of this bottom needle, then to the back between the two needles **(Figure 3)**. This forms the first stitch on the bottom needle. Point the needles downward, bring the bottom needle past the thumb yarn, then bring the thumb yarn between the two needles to the front then over the top needle **(Figure 4)**. There are now two stitches on the top needle.

Repeat from * until you have the desired number of stitches on each needle. Both needles should have the same number of stitches **(Figure 5)**.

Remove both yarn ends from your left hand, rotate the needles like the hands of a clock so that the bottom needle is now on top and both strands of yarn are at the needle tip **(Figure 6)**.

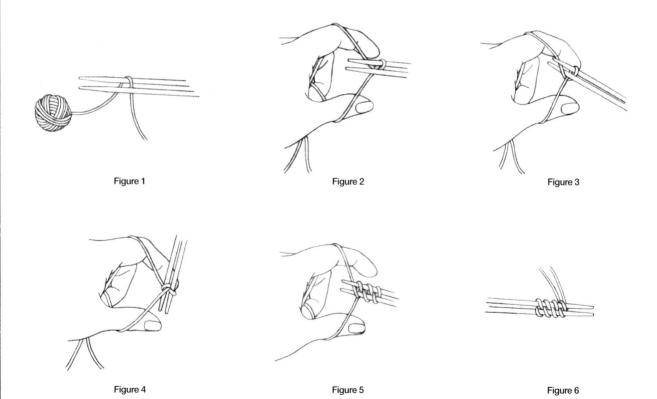

Figure 1

Figure 2

Figure 3

Figure 4

Figure 5

Figure 6

Long-Tail (Continental) Cast-On

Leaving a long tail (about ½" [1.3 cm] for each stitch to be cast on), make a slipknot and place on right needle. Place thumb and index finger of your left hand between the yarn ends so that working yarn is around your index finger and tail end is around your thumb and secure the yarn ends with your other fingers. Hold your palm upward, making a V of yarn **(Figure 1)**. ★Bring needle up through loop on thumb **(Figure 2)**, catch first strand around index finger, and go back down through loop on thumb **(Figure 3)**. Drop loop off thumb and, placing thumb back in V configuration, tighten resulting stitch on needle **(Figure 4)**. Repeat from ★ for the desired number of stitches.

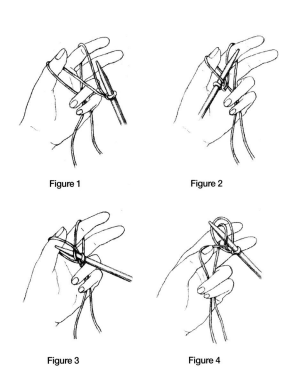

Figure 1 Figure 2

Figure 3 Figure 4

Provisional (Crochet Chain) Cast-On

With smooth, contrasting waste yarn and crochet hook, make a loose chain of about four stitches more than you need to cast on. Cut yarn and pull tail through last chain to secure. With needle, working yarn, and beginning two stitches from last chain worked, pick up and knit one stitch through the back loop of each chain **(Figure 1)** for desired number of stitches. Work the piece as desired, and when you're ready to use the cast-on stitches, pull out the crochet chain to expose the live stitches **(Figure 2)**.

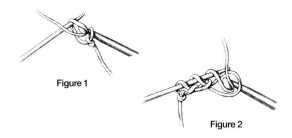

Figure 1

Figure 2

Tubular Cast-On for K1, P1 Rib (Odd Number of Stitches)

With contrasting waste yarn and using the backward-loop method, cast on half the number of stitches required plus one (total sts + 1, divided by 2). Cut the waste yarn. With main color yarn, work as foll:

Row 1: K1, ★yo, k1; rep from ★ to end **(Figure 1)**.

Row 2: K1, ★sl 1 pwise wyf, k1; rep from ★ to end **(Figure 2)**.

Row 3: ★Sl 1 pwise wyf, k1; rep from ★ to last st, sl 1 pwise wyf.

Rep Rows 2 and 3 once more.

Next row: K1, ★p1, k1; rep from ★ to end. Cont in k1, p1 rib as established, removing waste yarn after a few rows.

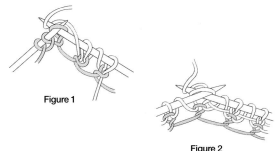

Figure 1

Figure 2

Crochet

Crochet Chain (ch)

Make a slipknot on hook. Yarn over hook and draw it through loop of slipknot. Repeat, drawing yarn through the last loop formed.

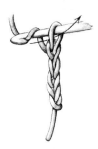

Decreases

Knit 2 Together (k2tog)

Knit two stitches together as if they were a single stitch.

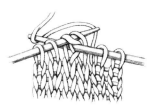

Purl 2 Together (p2tog)

Purl two stitches together as if they were a single stitch.

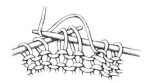

Slip, Slip, Knit (ssk)

Slip two stitches individually knitwise **(Figure 1)**, insert left needle tip into the front of these two slipped stitches, and use the right needle to knit them together through their back loops **(Figure 2)**.

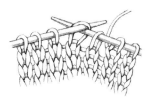

Figure 1

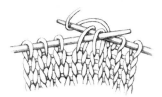

Figure 2

Gauge

Measuring Gauge

Knit a swatch at least 4" (10 cm) square. Remove the stitches from the needles or bind them off loosely and lay the swatch on a flat surface. Place a ruler over the swatch and count the number of stitches across and number of rows down (including fractions of stitches and rows) in 4" (10 cm) and divide this number by four to get the number of stitches (including fractions of stitches) in one inch. Repeat two or three times on different areas of the swatch to confirm the measurements. If you have more stitches and rows than called for in the instructions, knit another swatch with larger needles; if you have fewer stitches and rows, knit another swatch with smaller needles.

Grafting

Kitchener Stitch

This useful technique can be difficult for a begin-
ner simply because of the number of steps and the
order in which the stitches are worked. However,
once you learn the pattern and get into the rhythm
of the stitching, you'll find that grafting can go very
quickly and smoothly. Try knitting two swatches
and placing the live stitches on double-pointed
needles so you can practice the technique before
moving on to your project.

Arrange stitches on two needles so that there is an
equal number of stitches on each needle. Hold the
needles parallel to each other with wrong sides of
the knitting together. Allowing about ½" (1.3 cm)
per stitch to be grafted, thread matching yarn on a
tapestry needle. Work from right to left as follows:

Step 1. Bring tapestry needle through the first stitch
on the front needle as if to purl and leave the stitch
on the needle **(Figure 1)**.

Step 2. Bring tapestry needle through the first stitch
on the back needle as if to knit and leave that stitch
on the needle **(Figure 2)**.

Step 3. Bring tapestry needle through the first front
stitch as if to knit and slip this stitch off the needle.
Then bring tapestry needle through the next front
stitch as if to purl and leave this stitch on the needle
(Figure 3).

Step 4. Bring tapestry needle through the first back
stitch as if to purl and slip this stitch off the needle.
Then bring tapestry needle through the next back
stitch as if to knit and leave this stitch on the needle
(Figure 4).

Repeat Steps 3 and 4 until one stitch remains on
each needle, adjusting the tension to match the rest
of the knitting as you go. To finish, bring tapestry
needle through the front stitch as if to knit and slip
this stitch off the needle. Then bring tapestry needle
through the back stitch as if to purl and slip this
stitch off the needle.

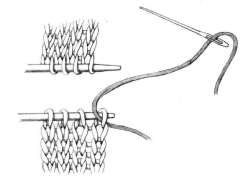

Figure 1

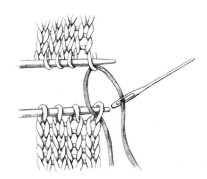

Figure 2

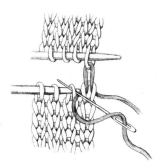

Figure 3

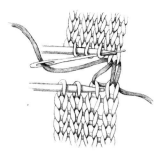

Figure 4

Increases

K1f&b (Bar Increase)

Knit into a stitch but leave the stitch on the left needle **(Figure 1)**, then knit through the back loop of the same stitch **(Figure 2)** and slip the original stitch off the needle **(Figure 3)**.

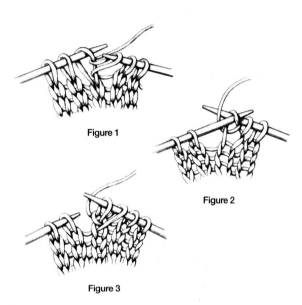

Figure 1

Figure 2

Figure 3

Make-One (M1) Increases

Note: *Use the left slant increase if no direction of slant is specified.*

Left Slant (M1L) and Standard M1

With left needle tip, lift strand between needles from front to back **(Figure 1)**. Knit lifted loop through the back **(Figure 2)**.

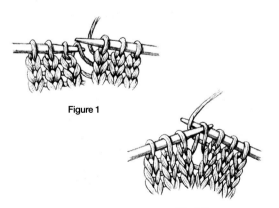

Figure 1

Figure 2

Right Slant (M1R)

With left needle tip, lift strand between needles from back to front **(Figure 1)**. Knit lifted loop through the front **(Figure 2)**.

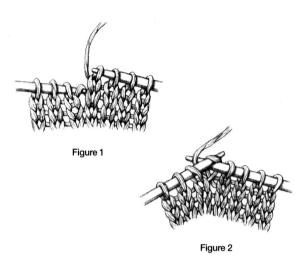

Figure 1

Figure 2

Purl (M1P)

For purl versions, work as above, purling lifted loop.

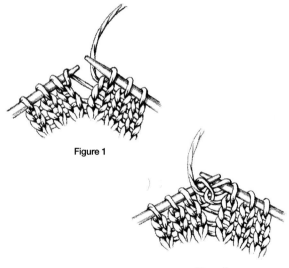

Figure 1

Figure 2

Joining for Working in Rounds

For projects that begin with ribbing or Stockinette st, simply arrange the stitches for working in rounds, then knit the first stitch that was cast on to form a tube.

For projects that begin with seed, garter, or reverse Stockinette st, arrange the needle so that the yarn tail is at the left needle tip. Holding the yarn in back, slip the first st from the right needle onto the left needle **(Figure 1)**, bring the yarn to the front between the two needles, and slip the first two stitches from the left tip to the right tip **(Figure 2)**, then bring the yarn to the back between the two needles and slip the first stitch from the right tip to the left tip **(Figure 3)**.

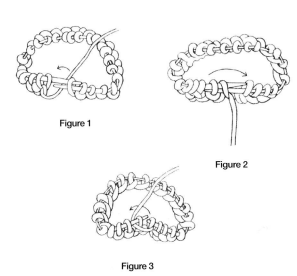

Figure 1

Figure 2

Figure 3

Magic-Loop Technique

Using a 32" or 40" (80 or 100 cm) circular needle, cast on the desired number of stitches. Slide the stitches to the center of the cable, then fold the cable and half of the stitches at the midpoint, then pull a loop of the cable between the stitches. Half of the stitches will be on one needle tip and the other half will be on the other tip **(Figure 1)**. Hold the needle tips parallel so that the working yarn comes out of the right-hand edge of the back needle. ★Pull the back needle tip out to expose about 6" (15 cm) of cable and use that needle to knit the stitches on the front needle **(Figure 2)**. At the end of those stitches, pull the cable so that the two sets of stitches are at the ends of their respective needle tips, turn the work around and repeat from ★ to complete one round of knitting.

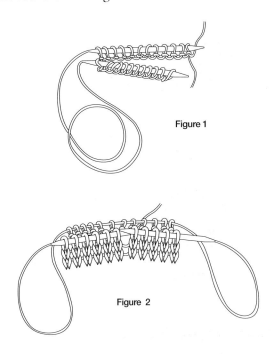

Figure 1

Figure 2

Pick Up and Knit

Along CO or BO Edge

With right side facing and working from right to left, insert the tip of the needle into the center of the stitch below the bind-off or cast-on edge **(Figure 1)**, wrap yarn around needle, and pull through a loop **(Figure 2)**. Pick up one stitch for every existing stitch.

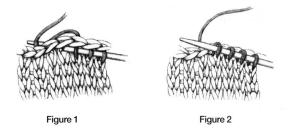

Figure 1

Figure 2

Along Shaped Edge

With right side facing and working from right to left, insert tip of needle between last and second-to-last stitches, wrap yarn around needle, and pull through a loop. Pick up and knit about three stitches for every four rows, adjusting as necessary so that picked-up edge lies flat.

Short-Rows

Knit Side

Work to turning point, slip next stitch purlwise **(Figure 1)**, bring the yarn to the front, then slip the same stitch back to the left needle **(Figure 2)**, turn the work around and bring the yarn in position for the next stitch—one stitch has been wrapped and the yarn is correctly positioned to work the next stitch. When you come to a wrapped stitch on a subsequent knit row, hide the wrap by working it together with the wrapped stitch as follows: Insert right needle tip under the wrap from the front **(Figure 3)**, then into the stitch on the needle, and work the stitch and its wrap together as a single stitch.

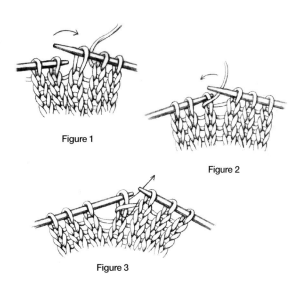

Figure 1

Figure 2

Figure 3

Purl Side

Work to the turning point, slip the next stitch purlwise to the right needle, bring the yarn to the back of the work **(Figure 1)**, return the slipped stitch to the left needle, bring the yarn to the front between

the needles **(Figure 2)**, and turn the work so that the knit side is facing—one stitch has been wrapped and the yarn is correctly positioned to knit the next stitch. To hide the wrap on a subsequent purl row, work to the wrapped stitch, use the tip of the right needle to pick up the wrap from the back, place it on the left needle **(Figure 3)**, then purl it together with the wrapped stitch.

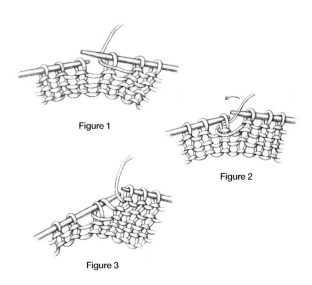

Figure 1

Figure 2

Figure 3

Weave in Loose Ends

Thread the ends on a tapestry needle and trace the path of a row of stitches **(Figure 1)** or work on the diagonal, catching the back side of the stitches **(Figure 2)**. To reduce bulk, do not weave two ends in the same area. To keep color changes sharp, work the ends into areas of the same color.

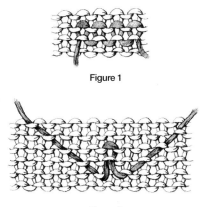

Figure 1

Figure 2

SOURCES FOR YARN

Berroco, Inc.

1 Tupperware Dr.
Ste. 4
N. Smithfield, RI 02896-6815
(401) 769-1212
berroco.com

Caron

320 Livingstone Ave. S.
Box 40
Listowel, ON
Canada N4W 3H3
(888) 368-8401
caron.com

Cascade Yarns

cascadeyarns.com

Illimani Yarn

1392 rue Victor Hugo
Montreal, QC
Canada H3C 5X4
(514) 867-2166
illimaniyarn.com

Lion Brand Yarn

135 Kero Rd.
Carlstadt, NJ 07072
(800) 258-9276
lionbrand.com

Louisa Harding

louisaharding.co.uk

Madelinetosh

3430 Alemeda St.
Ste. 112
Fort Worth, TX 76126
(817) 887-9988
madelinetosh.com

Western Sky Knits

wsknits.com

INDEX

Highland Knits. Copyright © 2016 by Interweave. Manufactured in USA. All rights reserved. No part of this book may be reproduced in any form or by any electronic or mechanical means including information storage and retrieval systems without permission in writing from the publisher, except by a reviewer who may quote brief passages in a review. Published by Interweave Books, an imprint of F+W Media, Inc., 10151 Carver Road, Suite 200, Blue Ash, Ohio 45242. (800) 289-0963. First Edition.

fw

a content + ecommerce company

www.fwcommunity.com

20 19 18 17 16 5 4 3 2

Distributed in Canada by Fraser Direct
100 Armstrong Avenue
Georgetown, ON, Canada L7G 5S4
Tel: (905) 877-4411

Distributed in the U.K. and Europe by F&W MEDIA INTERNATIONAL
Brunel House, Newton Abbot, Devon, TQ12 4PU, England
Tel: (+44) 1626 323200, Fax: (+44) 1626 323319
E-mail: enquiries@fwmedia.com

SRN: 16KN14
ISBN-13: 978-1-63250-459-3

Curated by Kerry Bogert
Editor: Michelle Bredeson
Technical Editor: Kristen TenDyke
Design Manager: Elisabeth Lariviere
Cover Designer: Frank Rivera
Interior Designer: Sylvia McArdle
Photographer: Chris Dempsey
Hair and Makeup: Marissa Prosser

We make every effort to ensure the accuracy of our patterns, but mistakes occasionally occur. Errata can be found at knittingdaily.com/errata.

METRIC CONVERSION CHART

To convert:	to:	multiply by:
Inches	Centimeters	2.54
Centimeters	Inches	0.4
Feet	Centimeters	30.5
Centimeters	Feet	0.03
Yards	Meters	0.9
Meters	Yards	1.1

MORE ENCHANTING DESIGNS FROM INTERWEAVE

THE BEST OF JANE AUSTEN KNITS

27 Regency-Inspired Designs

Edited by Amy Clarke Moore

ISBN: 978-1-62033-881-0

Price: $22.99

KNITTING WIZARDRY

27 Spellbinding Projects

Edited by Amy Clarke Moore

ISBN: 978-1-62033-848-3

Price: $22.99

CROCHET EVER AFTER

18 Projects Inspired by Classic Fairy Tales

Brenda K. B. Anderson

ISBN: 978-1-62033-750-9

Price: $24.99

knittingdaily

Join Knittingdaily.com, an online community that shares your passion for knitting. You'll get a free eNewsletter, free patterns, a projects store, a daily blog, event updates, galleries, tips and techniques, and more. Sign up at **Knittingdaily.com.**

INTERWEAVE KNITS

From cover to cover, *Interweave Knits* magazine presents great projects for the beginner to the advanced knitter. Every issue is packed full of captivating, smart designs, step-by-step instructions, easy-to-understand illustrations, plus well-written, lively articles sure to inspire. **Interweaveknits.com**

Available at your favorite retailer or shop.knittingdaily.com

knittingdaily shop